Christian Art: A Very Short Introduction

Very Short Introductions available now:

Available soon:

For more information visit our web site

www.oup.co.uk/vsi

Beth Williamson

CHRISTIAN ART

A Very Short Introduction

OXFORD
UNIVERSITY PRESS

Great Clarendon Street, Oxford O X 2 6 D P

Oxford University Press is a department of the University of Oxford.
It furthers the University's objective of excellence in research, scholarship,
and education by publishing worldwide in

Oxford New York

Auckland Bangkok Buenos Aires Cape Town Chennai
Dar es Salaam Delhi Hong Kong Istanbul Karachi Kolkata
Kuala Lumpur Madrid Melbourne Mexico City Mumbai Nairobi
São Paulo Shanghai Taipei Tokyo Toronto

Oxford is a registered trade mark of Oxford University Press
in the UK and in certain other countries

Published in the United States
by Oxford University Press Inc., New York

British Library Cataloguing in Publication Data

Data available

Library of Congress Cataloging in Publication Data

Data available

ISBN 0-19-280328-X

1 3 5 7 9 10 8 6 4 2

Typeset by RefineCatch Ltd, Bungay, Suffolk
Printed in Great Britain by
TJ International Ltd., Padstow, Cornwall

Contents

List of illustrations

The publisher and the author apologize for any errors or omissions in the above list. If contacted they will be pleased to rectify these at the earliest opportunity.

List of diagrams

Introduction

Unlike other terms that might be used to categorize art, 'Christian art' is unusual in that it does not describe art of a particular style, period, or region, but art for a particular range of purposes, which encompasses a wide range of forms and styles. Because of this the range of material that could be covered in a book on the subject is potentially vast. I have chosen to focus only on pictorial art – paintings, prints, manuscripts and printed books – not on architecture, nor on sculpture, nor 'applied arts' such as metalwork or textiles. The choice as to how to limit such a large range of material will inevitably be somewhat arbitrary and personal, and the particular examples discussed here are not even selected qualitatively: this book does not attempt to delineate a range of the 'greatest masterpieces' of Christian art. Instead, some central themes have been chosen, which allow certain important ideas and concepts relating to Christian art to be considered. The examples selected allow those themes, ideas, and concepts to be explored in a variety of ways: the same ideas could almost certainly be discussed using an entirely different set of examples.

A particularly fascinating aspect of the study of Christian art is that it touches upon such a wide range of other subjects: history, politics, theology, philosophy, to name but a few. Christian art began within the restricted confines of minority communities, initially persecuted for their beliefs. Over its two millennia of existence it

developed into having an almost universal presence in the public buildings and private spaces across what was known as 'Christendom', the territories in which Christianity held sway. Christian art would be seen in cathedrals, abbeys, and great churches, royal palaces, government buildings and public spaces, as well as in smaller parish churches, private homes, and even in apparently secular spaces such as shops and markets. Christian imagery could be seen in great cycles of wall-paintings and mosaics on church walls, which told the universal stories of Christian history. It could be seen on smaller paintings on wood panels, or cloth, designed to be set up in churches, or carried in processions. Books, for church services, and for private reading and prayer, carried illustrations of the Christian texts included, and Christian images appeared on many of the other accoutrements of Christian worship and devotion, such as the vestments of churchmen, the precious metalwork vessels used in church services, and the reliquaries and shrines in which the remains of holy men and women were venerated. Kings and rulers used Christian imagery to bolster their own ideologies and political rhetoric, and groups of ordinary citizens rallied around favoured examples of Christian art, objects that were regarded as miraculous or in other ways particularly special to a local community or social group. During the late Middle Ages, Christian art was part of an expression of an apparently universal world-view. Then, with changes and developments to the theology and practice of Christianity itself, and the formal emergence of different denominations or groupings under the wider umbrella of Christianity, more specific types and forms of Christian art became associated with the variant views of Christianity promoted by different groups, with Christian art even being rejected entirely in some circles. It will be seen, throughout this book, that Christian art, besides offering 'illustrations' of biblical stories and theological messages, is often also used to express particular political views, philosophical ideas, and cultural identities, and that in some contexts the very existence, or not, of Christian art – let alone the specific aspects of particular objects and images – can become an explicitly political or ideological statement.

The status of images in early Christianity

Looking back at the history of Christian art through the prism of its very ubiquity in the Middle Ages, and its diversity in the early modern and modern world, it is sometimes hard to remember that the very development of Christian art itself was not inevitable or unproblematic. Christianity developed out of the religious culture of Judaism, and availed itself of Judaic theology and prophecy in what became the Old Testament, the first part of the Christian Bible. The Jewish holy scriptures recounted the creation of the world, the stories of Adam and Eve, and Moses, who received the Ten Commandments from God, and who led the Jews out of slavery in Egypt to the Promised Land. These stories, together with the later Greek writings that told of the life of Jesus Christ and of his followers, the Apostles, came to form the source material for much Christian art. However, Judaism had prohibited the pictorial representation of God, and was deeply suspicious of representational religious art because of a fear of idolatry. Old Testament writings defined idols as objects made by man, which contain no divine essence and which are not, therefore, appropriate to represent the divine. But Christianity as it developed in Europe, from Rome, also took much from Graeco-Roman social and artistic culture, where images of divinities, and their deeds, were not proscribed in the same way. This affected one crucial way in which Christianity differed from Judaism, namely the centrality of artistic representations of the Christian God. In adapting Graeco-Roman pagan imagery to form images of Christ, and in developing and multiplying images of Christ, the emergent Christian church went against Judaism's prohibition regarding images and idols, and this helped to mark out the developing church as distinct from the religious and theological culture of Judaism. The very existence of Christian art is therefore one of the things that makes up the specific and fundamental character of Christianity.

Catacomb paintings

The earliest surviving Christian art is found in Rome, in the catacombs – the elaborate underground tomb chambers in which the Christian communities buried their dead. There is some uncertainty as to the date of the earliest catacomb paintings, but according to current opinion, it would seem that the earliest Christian catacombs, and their wall-paintings – carried out in fresco and tempera – probably date from the 3rd century. This visual material is relatively small-scale and private, occurring as it does in a funereal context, and the subjects chosen for representation tend to be those appropriate to private tombs, with an emphasis on hope and comfort. Perhaps surprisingly, images of Christ's death at the Crucifixion, which later became such a fundamental subject of Christian art, are rare in the catacombs. Perhaps at this point in the development of the emerging Christian church, direct portrayals of Christ's own violent death seemed less immediately or obviously redolent of hope than other images that more generally symbolized protection and deliverance.

The image of the shepherd is a particularly popular one in early Christian art, occurring over 100 times in the catacombs as a whole. The shepherd symbolizes care and protection, as prefigured in the 23rd Psalm ('The Lord is my shepherd; I shall not want. He makes me to lie down in green pastures; he leads me beside the still waters. He restores my soul.') The shepherd had already appeared in Greek art, with the god Hermes sometimes being portrayed carrying a sheep or a ram. Pagan imagery of Hermes in this aspect was adapted by Christians to form the image of Christ the Good Shepherd (Fig. 1).

Besides Old and New Testament images referring to deliverance, and representations of the Good Shepherd, the catacombs also contain depictions of New Testament narratives, such as the Annunciation and the Breaking of Bread at the Last Supper, both of

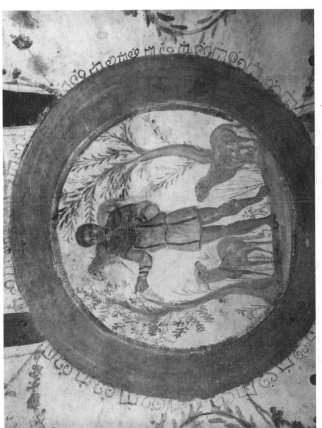

1. *The Good Shepherd*, Rome, Catacomb of Marcellinus and Peter, 4ᵗʰ century

which images will be considered later in this book. Episodes of deliverance from death and triumph over death are also represented many times throughout the catacombs, such as Daniel in the Lion's Den, or the Three Men in the Furnace, from the Book of Daniel. In the miracle of the Raising of Lazarus, from the Gospel of John, a man who had already been dead for several days was brought back to life by Christ. This miracle was an important and concrete demonstration of the triumph over death, and was, therefore, an obvious one for the emergent Christian church to use in its visual rhetoric.

The character of Christian art changed, or expanded, after the official recognition of Christianity by the Roman Emperor Constantine, in 313 CE, and the later establishment of Christianity as the sole state religion within the Empire. The state that developed under these early Christian emperors was a continuation of the Roman Empire, but centred on the city of Constantinople (now the Turkish city of Istanbul), founded by Constantine in 324. The original name of Constantinople was Byzantium, which gives the state and its rulers the name by which scholars refer to it today: Byzantium, or the Byzantine Empire. The Byzantine emperors in fact regarded their state as 'the Roman Empire', and in its early years the area they ruled embraced most of the territory of the former Roman Empire right around the Mediterranean. Changing political events and the personal circumstances of successive emperors meant that the administrative centre of the Empire shifted several times during the early phases of the development of Byzantium, with the result that the major monuments of early Christian art from this period are found in several centres besides Constantinople, including the Italian cities of Milan and Ravenna.

Mosaics

Much of the most significant early Christian art of this period is the architectural decoration – mostly mosaics – in the major new Christian churches, including the huge church of Hagia Sophia

(Saint Sophia), founded in Constantinople by the Emperor
Justinian in 532–7, and the churches of Sant'Apollinare and San
Vitale, founded in Ravenna in *c.* 500 and in 548 respectively.

The art to be found in these churches differs significantly from the
catacomb paintings in both form and content. It is large-scale,
monumental, and authoritative, often linking Christian imagery
with official and imperial imagery. However, the decoration in these
Byzantine churches has at least one thing in common with the
catacomb paintings: it largely eschews the image of the Crucified
Christ which was later to become so central to western European
Christianity. Where western, later medieval Christian churches
would be dominated by large-scale crucifixes, raised high at the east
end of a long nave, the figural decoration of Byzantine churches
tended to centre around the image of the blessing Christ, placed in
the inside of the dome over the centre of the church, or in the curved
apse of the sanctuary. In San Vitale, the blessing Christ over the altar
is approached by the patron saint of the church, Vitale, and by the
church's founder, Bishop Ecclesius, each of whom receives a crown
of virtue from Christ. Below the Christ mosaic, to left and right, are
framed mosaic panels depicting processions including the Emperor
Justinian and his wife, the Empress Theodora (Fig. 2). The
Emperor Justinian (in the centre, wearing the imperial crown) is
accompanied by members of his court and the military. Although
the image of the Emperor Justinian is frontal, facing outwards,
parallel to the picture plane, there are suggestions that the
procession moves from left to right, towards the altar, as though
taking part in church ceremonial. The soldiers at the far left of the
image are turned to the right, and the figures who stand between
them and the Emperor lean to the right. The Emperor's hands, with
the offering of gold plate that he is making to the church, point to
the right, where we see Bishop Maximianus (labelled by the
inscription above his head) and his religious attendants. The slight
turn of the bodies of these figures, and the gesturing hand of the
person on the far right, lead the observer's eye to the right, towards
the altar.

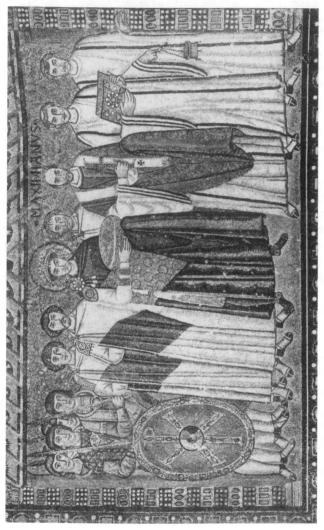

2. *Procession with Bishop Maximianus and Emperor Justinian, Ravenna, S. Vitale, c. 548*

It has been suggested by Robert Milburn that these mosaics hint that 'the earthly kingdom of the emperor in some sort reflects the heavenly rule of Christ', and, indeed, other major Byzantine churches make similar links, depicting emperors in close contact with Christ (e.g. *Emperor John II Komnenos and Empress Irene flanking the Virgin and Child*, 1118, Istanbul, Hagia Sofia). This sort of explicit interlocking of Christian and imperial or royal imagery is not, in fact, unique to the Byzantine emperors, and can be seen in different ways throughout eastern and western Christianity. Rulers, kings, princes, and dukes can be seen in the company of the Virgin, Christ, and the saints, in small artworks designed for private prayer and contemplation as well as in large-scale public monuments. Later in the medieval period, non-royal or imperial donors and patrons of artworks inserted themselves into Christian imagery also, so that images of ordinary mortals can be seen in the company of the divine, sometimes presented to the Virgin and/or Christ by their patron saints. Such images were produced as a means of indicating the donors' own devotion, but also, in the case of large-scale or public works, as a means of commemorating their piety and generosity in having such an artwork made (see Chapter 3).

Icons

Besides the monumental mosaic programmes of the major Byzantine churches, the other significant Byzantine art form that needs to be discussed in this introductory chapter is the icon. The way in which art-historians use the term 'icon' is narrower than the Greek word *eikon*, from which it derives, and which includes all sorts of images. When used in English-speaking theological or art-historical writing, the term describes a painting on panel, depicting a sacred subject, intended to be the focus of ritual or cultic veneration. The earliest surviving icons date from the 6th century, although it is clear that they existed earlier than this. Despite the Old Testament prohibition of image or idol veneration, early Christian texts make it clear that icons were venerated by Christians

from as early as 200 CE. As with the adaptation of Graeco-Roman images to create images of Jesus Christ, the veneration of icons was recognized as being an adaptation of pagan practice, which made the process and its development extremely controversial, as we shall see. The visual form of Byzantine icons also descended directly from the tradition of Roman portrait painting, with an extraordinary degree of apparent realism. The portrait character of icons was crucial because, in these images, Christians believed that they saw a true and authentic likeness of the holy person there portrayed. In fact, despite this claim to historical accuracy, early icons of Christ seem to be based more upon a general facial type that had already become associated with the great male gods of ancient Greece and Egypt. The Greek father-god Zeus, and other similar divinities, were portrayed with long hair and a full beard, and this became the standard type for Christ also.

Certain other icons were regarded as being authentic portrait likenesses because they were painted from life, by an artist in direct contact with the holy person portrayed. It was widely believed, throughout the early Christian and medieval periods, that an icon of the Virgin, which resided in the monastery of the Hodegetria, near the church of St Sophia in Constantinople, was a contemporary portrait, painted by St Luke the Evangelist. The icon kept there was known after the place in which it resided, and was called the Hodegetria icon or the Virgin Hodegetria. The original was lost after the Turkish conquest of Constantinople in 1453, but is known from copies. These copies, and their relationship with the original, were regarded differently at this period from the ways in which copies and originals have been regarded in the modern history of art. A Byzantine viewer would have expected to see icons copied and replicated, and would have regarded a replica of the Hodegetria as a copy of the authentic original, thus retaining some of the authority of its model.

It was believed that the Hodegetria icon had been brought to Constantinople from Jerusalem, by the Empress Eudokia, wife

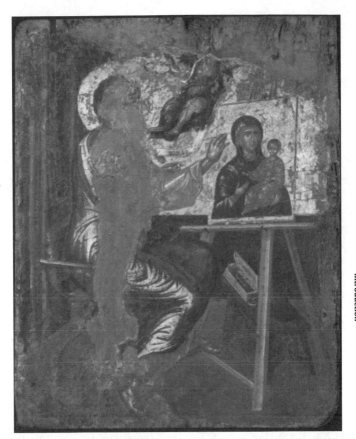

3. El Greco (Domenikos Theotokopoulos), *St Luke Painting the Virgin*, Athens, Benaki Museum, *c.* 1560–7(?)

of Emperor Theodosius II, in the mid-5th century. The icon was regarded as a portrait of the Mother of God, having been painted by St Luke in the Holy Land, during the lifetime of Christ and his mother. Thus Luke gained a status not just as a writer of one of the four gospels, but also as the first Christian artist. Artists found the idea of St Luke painting the Virgin an irresistible subject in itself, and many painted representations of the event.

El Greco's depiction of the subject (Fig. 3) is doubly interesting for it is itself an icon, and therefore depicts an icon within an icon. Although the painting is badly damaged, the composition allows the viewer to see the original Hodegetria icon in its well-known form, with the Virgin gesturing with her right hand towards the child. This particular image of the Virgin, with the pointing gesture, was replicated over and over again in icons, but also in western panel paintings of the Virgin and Child that derived their form from Byzantine icons (see Chapter 1, Fig. 4). As with images of the Evangelists writing their gospels, this painting includes an angel, who gives approval to St Luke and authority to his image by placing a laurel wreath on the Evangelist's head. In this way, El Greco's icon affirms the orthodoxy and authority of religious images in general, and of this sort of icon in particular. It does so eight centuries after the very existence of religious images and icons and their veneration in a Christian context came under threat during the Iconoclastic ('image-breaking') controversy of the 8th and 9th centuries, in which icons became the subject of fierce political and theological debate. During this controversy icons were systematically removed from churches and destroyed, before an imperial settlement of the question ruled in favour of the existence and use of icons. Broadly speaking, the iconoclastic movement stemmed from a rekindling of doubts about Old Testament prohibitions against the making of idols and against idolatry. The Byzantine Emperor Leo III (717–41) removed an icon of Christ that had been publicly displayed over a gate of the imperial palace, and promulgated an edict against icons in 726. His son Constantine V (741–75) continued Leo's stance, and churches were stripped of their icons.

The theological position of the iconoclasts – beyond the scriptural prohibition of idolatry – was broadly an objection to the impossibility of accurately representing Christ in icons. This was because it was believed that such images could only depict his human nature, not his divinity, and that therefore the making and venerating of icons of Christ threatened to separate his two natures. As well as this, the iconoclasts reasserted the dangers of idolatry,

arguing that the making of icons might encourage people to worship material objects or images, rather than to direct their devotion to God, the proper recipient of worship. Those who supported the making and use of icons, the 'iconophiles' (image-lovers) stressed that icons of Christ should be seen as a demonstration of Christ's human nature without detracting from his divine nature. In addition, they argued that icons allowed people to worship Christ *through* the icon. The Council of Nicaea, arranged by the Empress Irene in 787, explained the position thus:

> the honour which is paid to the image passes on to that which the image represents, and he who does worship to the image does worship to the person represented in it.

This church council supported the use and the making of icons, but the question was not yet resolved. In 813 Emperor Leo V revived the iconoclast position, but the Empress Theodora, widow of the Emperor Theophilus (829–42) managed the final settlement of the controversy in 843 with an imperial edict in favour of icons and their use. Theodora's son Michael III (842–67) then restored the icon of Christ that Leo III had removed back to its position over the palace gate, and oversaw the production of icons for major public locations, including major mosaic icons of the Virgin and of the saints for Hagia Sophia. After 843 icons became established as symbols of the identity of the Orthodox believer, and the belief in St Luke's production of the Hodegetria icon of the Virgin was one of the central planks of support for icons. The idea of St Luke as an artist as well as a writer promoted Christian images to a rank equivalent to that of the Christian gospel texts. It also offered unassailable support for the making of icons in that a saint – and a saint with the undeniable authority of an Evangelist – had confirmed that the making of icons of the Virgin and Christ was justifiable. St Luke's authority, and the orthodoxy of icons, together with the special status of the Hodegetria icon in Constantinople, and the power of the Christian artist to make manifest the true image of holy persons, are all celebrated in El Greco's own icon.

From the 9th century onwards, then, Christian art was firmly embedded within Christian doctrine and worship. It was created and used differently in the different regions in which Christianity held sway, but the idea that religious images were generally both permissible and desirable was not to be seriously or universally challenged again. There would still be different attitudes towards the ways in which images should be used, and disagreements about the correct or appropriate forms of Christian art. But even after the Protestant Reformation in the 16th century (see Chapter 5), where reformers reacted against the perceived extravagance of Catholic church interiors, and what they saw as over-reliance on images at the expense of the Word, Christian art was abandoned completely only by a small sector of the Christian church. The production of Christian art goes on, in many of the same ways that it has since the 9th century, in public, monumental artworks for churches and ecclesiastical buildings, as well as in smaller scale, more private works. In addition, Christian imagery has become part of the fabric of western culture, and has become part of the wider artistic and cultural vocabulary of modern image-makers, not only fine artists, but also film-makers, illustrators, graphic designers, commercial product designers, and those who design and create advertisements, the visual form that accounts for perhaps the greatest percentage of image-making that we see in the modern world. This world is an increasingly secular one. It is termed by some – even by some Christians – a post-Christian world, which is not to say that Christianity no longer has any relevance, but that Christianity is no longer so vastly dominant in religious, intellectual, and cultural terms as it once was. Nevertheless, the enormous historical importance of Christianity, and the pervasiveness of Christian art and imagery throughout the past 2,000 years, means that it is still essential to understand something of this pictorial vocabulary of Christianity, and the ideas behind some of its main themes, in order to be fully visually literate in this modern world.

Chapter 1
The Virgin Mary

One of the central tenets of Christianity is the incarnation – the 'being made flesh' – of Jesus Christ. The doctrine of the incarnation insists upon the dual nature of Christ – fully divine and also fully human – and therefore insists upon his real birth, as a human being, from a real, human mother. It is for that reason that images of Christ's mother, Mary, appear so frequently in Christian art: the existence of his human mother is a proof of Christ's own humanity, and she is venerated on account of her motherhood of Christ. But the birth of Christ was not an ordinary human birth: he was born to a virgin, and thus had no human father. This aspect of the story of Christ's birth emphasized his divinity, and supported the Christian doctrine that stated that he was the Son of God. Virgin birth had been a sign of divinity or heroic status in classical mythology, and therefore the Christian church was not alone in emphasizing the virgin birth of its central figure. However, Christianity put quite exceptional stress upon Mary's virginity, both before the birth of Christ, and afterwards. Thus Mary's husband, Joseph, is often relegated to a position of little importance, even in images portraying the story of the Nativity of Christ.

Many visitors to galleries and churches will have had the experience of seeing what can sometimes appear to be endless numbers of images portraying the Virgin Mother and her child. The representation of Christ's mother, dressed in her traditional blue

robe, enthroned, with the Christ-child on her knee, or shown half-length, holding the child in her arms, is an absolute staple of Christian art. A 13th-century Italian Madonna and Child, now in the National Gallery in London, and attributed to the Umbrian 'Clarisse Master' (Fig. 4), conforms to a very standard medieval type of this image. The content and size of this panel indicate that it was probably designed for an individual, for private devotion and prayer. In its original form the painting may have been a triptych, a three-panelled painting, with wings or shutters attached to each side of the main panel, which would have shut over the central image and which would perhaps have depicted saints, or additional christological narrative scenes.

The presentation of the Virgin in this image is based upon that of Byzantine icons which were imported into Italy during the 13th century. The child presses his face close to his mother's in a gesture recalling the Byzantine icon-type known as the 'Elousa', which expresses tenderness and mercy. While the child looks up at his mother, she gazes out of the picture, with a pensive, poignant expression. This might be intended to convey an awareness of the fate of her son, a fate which is already ordained (see Chapter 2). Besides the position of the figures, the blue mantle and scarlet inner head-dress were also derived from icons, as we can see from the Virgin icon depicted within El Greco's *St Luke Painting the Virgin* (Fig. 3). The blue mantle survived almost unchanged for Italian Virgin and Child images, although the red inner head-dress was fairly quickly relinquished, replaced by a softer white veil on top of, or inside, the blue mantle. Here, in the Clarisse Master's *Virgin and Child*, we see both the inner head-dress and the white veil, indicating that this panel is a fairly early Italian response to a Byzantine icon-type. The gold lines on the mantle and the veil – also derived from Byzantine icons – were to become archaic and obsolete in Italian painting before long. Despite these relatively small changes of detail and decoration, however, this general type was sustained throughout the 14th and into the 15th century. This type of Virgin and Child still remains in many churches, particularly

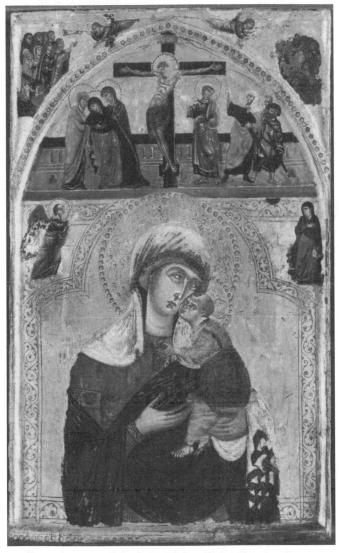

4. Clarisse Master, *Virgin and Child*, London, National Gallery, c. 1265–75.

in Italy, as well as appearing frequently in museums and galleries throughout the world.

The image's portrayal of the Virgin Mother and her child encourages the viewer to consider certain theological and doctrinal issues, such as the incarnation of Christ and the virgin birth, and, more simply, to offer devotion and veneration to the holy persons portrayed. Beyond its affirmation of the Virgin's maternal relationship with Christ, however, it does not tell the viewer very much about the Virgin. For further detail on the Virgin and her life, one might expect to turn to the Bible, which provides a good deal of source material for many aspects of Christian art. But it may surprise some viewers of art to discover that the Bible is, in fact, relatively quiet on the subject of the Virgin Mary. She appears fleetingly in two references in the Gospel of Mark (Mark 3: 31 and 6: 3) and in two references in the Gospel of John (John 2: 1–12, the wedding at Cana, and 19: 25–7, Mary and John at the foot of the cross). In the Acts of the Apostles the Virgin prays with the Apostles after Christ's ascension into heaven (Acts 1: 12–14), and St Paul, in his Letter to the Galatians, mentions that Christ was born of a woman (Galatians 4: 4). Every other detail about the Virgin in the New Testament comes from the sections of the Gospels of Matthew and Luke concerning Christ's infancy, both of which narratives are regarded as being later additions to these Gospel texts, written perhaps 80 years after the events that they describe. Matthew's Gospel recounts Christ's genealogy and then gives an account of his birth, starting with Joseph's awareness that Mary, his betrothed, was 'found to be with child through the Holy Spirit' (Matthew 1: 18). Matthew mentions the visit of the magi, the wise men from the East (2: 1–12), the flight of the Holy Family into Egypt, and King Herod's massacre of the innocents (2: 13–18), and the return of the Holy Family to Nazareth (2: 19–23). By the third chapter of Matthew's Gospel Mary disappears from the narrative, other than for a few extremely fleeting mentions where, for instance, people identify Christ as the son of a woman called Mary. Luke's Gospel gives the most extensive account of the birth and infancy of Christ, and

within the first two chapters of that Gospel we learn most of what we know about the Virgin, with descriptions of the Annunciation (the message of the angel that the Virgin is to bear a son), the Visitation (the visit of Mary to her cousin Elizabeth, the mother of St John the Baptist), the Magnificat (the Virgin's hymn of joy), the birth of Jesus, and the visit of the shepherds. It is only in this section of the Gospel that the Virgin appears centrally in the drama. After these events, the Virgin is mentioned in the account of the circumcision of Christ and his presentation in the Temple. Just after this, she speaks directly, in one of only a few such instances, in the episode that marks the transition from Christ's infancy to his adult life. Christ's parents do not know where he is, and are worried. They eventually find him disputing with the learned men in the Temple at Jerusalem (Luke 2: 41–52). The Virgin remonstrates with Christ, whereupon she is told by him that he has been about his father's business, by which he means that he has begun his public ministry. Very soon, as with the Gospel of Matthew, the Virgin slips out of the narrative, returning only very briefly and in passing thereafter.

With these scant Gospel accounts we have the majority of biblical source material for the common narrative images of the Virgin Mary. The Gospel narratives treat her story as coterminous with that of Christ's infancy. Her life appears to be regarded as largely unimportant other than as the mother of Christ, and little attention is given to any detail outside that role. Much of the other detail about the Virgin's life was supplied by non-biblical texts such as the Apocryphal Gospel of James (probably 2nd century) and of Pseudo-Matthew (a later medieval development and expansion of the Book of James), and the *Legenda Aurea*, or *Golden Legend*. This highly influential 13th-century preachers' handbook was translated into every major European language, and some 1,000 manuscripts survive from the medieval period. (It was even more widely disseminated and read after the advent of printing.) In this text the writer, Jacobus de Voragine (James from Varazze, a town on the Genoese Riviera) drew together all the various sources available to him on the lives of Christ, the Virgin, the saints, and various feasts of the church. It is from this

text, together with the Apocryphal Gospels, that we get the sources for images of the Virgin which depict events that took place before the Annunciation, such as her birth, and her marriage to Joseph, and events that take place after Christ's Resurrection and Ascension, such as the Virgin's own death and the Assumption, at which her body and soul were taken up into heaven. In addition, these non-biblical texts supply much additional detail about established biblical narratives, which artists used in their depiction of these events, to augment the sparse detail of the biblical text.

The Annunciation

The most commonly illustrated Marian narrative is the Annunciation, the moment when the Angel Gabriel, sent from God to Mary, tells her that she has been chosen by God to be the mother of Christ (Luke 1: 26–38). This event quickly became understood not just as the moment at which the Virgin became aware of her destiny as the mother of God, but also as the moment at which, following her acceptance of this destiny, the incarnation of Christ actually took place. It was at this moment that 'The Word was made flesh', as John's Gospel puts it (John 1: 14). Representations of the Annunciation appear as early as the 4th century, and the event is represented continuously throughout Christian art. The essentials remain the same: an angel (whose status as such is normally indicated by the possession of wings) approaches a woman, with a hand raised in a gesture indicating speech. Often he – although angels theologically have no gender, they are often represented as young males, albeit fairly androgynous – holds a staff in his other hand which, by the late Middle Ages has often become transformed into a lily stem, a traditional indicator of the Virgin's purity. Sometimes lily stems may be shown in a vase on the floor beside the Virgin, instead of, or in addition to being held by the angel. Nothing can be gleaned from Luke's Gospel as to the physical setting in which the Annunciation took place, except that Luke says that the angel 'went in and said to her, "Rejoice"' (Luke 1: 28). From this, most artists deduced that the event took place in an interior, or a

semi-interior, such as an open porch or loggia. In the simplest, earlier versions of the image, both figures usually stand. Later the Virgin sits, stands, or kneels, sometimes at a reading-stand or a prie-dieu, a low bench with a narrow reading desk attached. Occasionally the Virgin is shown sewing, or winding wool, alluding to the legend of the Virgin's upbringing in the Temple at Jerusalem, and the task she was given by the priests of weaving a veil for the Temple. Most often, however, she is reading, or has been reading, a book, which lies open on her lap or in her hands (e.g. Master of the Mérode Triptych, New York, Metropolitan Museum, Cloisters Collection, c. 1440), or on the prie-dieu (e.g. El Greco, Budapest, Svepmuvestzeti Museum, c.1600). Sometimes the book is semi-closed, with the Virgin marking her place with a finger or thumb inserted between the pages (e.g. Simone Martini, Florence, Uffizi, 1333), or is still open, but has been set aside (e.g. Nicolas Poussin, London, National Gallery, 1657). When the book is open we can sometimes see the text on its pages, and sometimes artists have made an effort to make the text legible. In these instances, we sometimes see that the Virgin is reading from the Old Testament, specifically the prophecy of Isaiah 7: 14 ('A virgin will conceive, and she will bear a son'). This prophecy emphasizes the destiny of the Virgin Mary, and makes it clear that the moment of the Annunciation marks the transition from the era of the Old Testament into the age of the New Testament, with the incarnation of Christ.

The ways in which the book is handled by the Virgin can sometimes indicate a specific moment in the narrative of the Annunciation. Luke recounts the narrative in stages, involving a dialogue between the angel and the Virgin: the angel goes in and greets Mary ('Rejoice, so highly favoured! The Lord is with you', 1: 28); the Virgin is disturbed by this, and wonders what this can mean (1: 29); the angel reassures her ('Mary, do not be afraid; you have God's favour. Listen! You are to conceive and bear a son, and you must name him Jesus', 1: 30–1); Mary is unconvinced ('But how can this come about, since I am a virgin?', 1: 34); the angel explains that this will be by the agency of the Holy Spirit ('"The Holy Spirit will come upon you" the angel answered', 1: 35); the Virgin accepts what has

been said, and accepts her destiny as Mother of God ('Behold the handmaid of the Lord . . . let what you have said be done to me', 1: 38). If the Virgin is still reading her book (e.g. Carlo Crivelli, London, National Gallery, 1486), the viewer may imagine that the angel has just arrived, and has just uttered, or is just about to utter, his first words of greeting. If the Virgin has looked up from her book, and is looking at the angel (e.g. Francisco de Zurbarán, Philadelphia Museum of Art, 1650), the moment portrayed may be further on in the narrative, perhaps the Virgin's question to the angel. If the Virgin's attention is no longer absorbed by the book, and she places one hand on her chest, or crosses her hands in front of her, with her head slightly inclined downwards, it is probable that we see the moment of the Virgin's submission or acceptance (e.g. Fra Angelico, Florence, S. Marco Corridor, *c.* 1450).

While the Virgin's submission or acceptance of her destiny was an especially popular subject from the Middle Ages to the modern period some artists have also dealt strikingly with the tension of the early moments of the narrative. Dante Gabriel Rossetti's version of the Annunciation, *The Girlhood of Mary Virgin* (Fig. 5), creates a real sense of foreboding, with the presence of what seems, at first glance, to be a small boy, dressed in white, standing to the left. Then one notices his red wings, folded to his sides, which indicate that he is, in fact, an angel. He fiddles with the leaves of a tall lily stem in a pot, balanced on a pile of books. The Virgin has glanced up from her needlework, and sees the angel-figure, although the Virgin's mother, St Anne, has not yet noticed him. The Virgin's expression is still: one cannot tell at this moment what her reaction will be, although viewers versed in the traditions that this painting addresses know that as soon as the angel speaks, as he surely will, the Virgin will go through disquiet, disbelief, and finally acceptance. The dove, symbolizing the Holy Spirit, by whose agency the Virgin will imminently become pregnant, perches in the window at the threshold of the room. The drama of this particular representation lies in the way in which the artist has persuaded the viewer that we witness the moment *just fractionally before* the dialogue that Luke recounts.

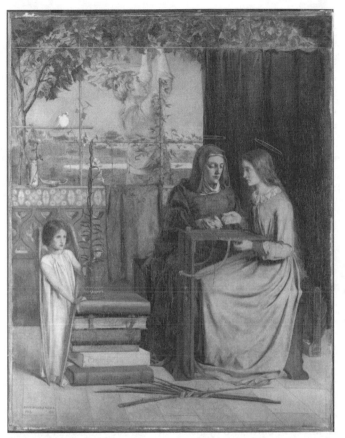

5. Dante Gabriel Rossetti, *The Girlhood of Mary Virgin*, London, Tate Gallery, 1849

Books of Hours

The Annunciation is an image that we very frequently see represented in manuscripts also, particularly in Books of Hours. These manuscripts have been described as 'a late medieval best-seller'. They were produced as personal prayer books for laypeople, although their format and contents were derived from the Breviary,

the servicebook used by monks, friars, and canons in religious communities for the performance of the 'Divine Office', recited throughout the day. As the Divine Office developed, extra 'offices', or sets of prayers and devotions, were added to the Breviary, and one of these was a short office in honour of the Virgin Mary, which seems to have developed first around the 10th century. It was this office, known as the 'Little Office of the Virgin Mary' which was eventually abstracted from the Breviary to form the nucleus of the Book of Hours. The earliest known English example of an independent Book of Hours appears to be the mid-13th-century manuscript produced by William de Brailes (London, British Library, Add. MS. 49999, *c.* 1230–60) and hence known as the De Brailes Hours. The most splendid manuscripts were owned by kings, princes, and the aristocracy, but less expensive Books of Hours were produced in great number, and were within the financial reach of the urban merchant classes. Wills tell us that even a 15th-century London grocer could own a 'primer' (the common English term for a Book of Hours). With the advent of printing, accessibility and ownership was widened even further, and it is estimated that over 50,000 of these books were published for the use of English laypeople in the late 15th and early 16th centuries. Some of these would have been expensive, richly decorated productions, but others would have been small, cheaply produced books, costing perhaps only a few pence to buy. This pattern was replicated in France, where manuscript workshops in the 15th century began to turn out large numbers of 'off-the-peg' Books of Hours, to be purchased by merchants and shop owners in Paris, Bruges, and other cities, and the advent of printing had the same effect of mass-production as in England.

In a Book of Hours, each hour is dedicated to a different episode of narrative, so that the recitation of the whole office produces a set of opportunities to contemplate a linked series of events. Appropriately enough, in many Books of Hours, the texts of the different hours are illustrated by a series of episodes concerning the Virgin and the infancy of Christ, beginning with the Annunciation,

and usually ending with the Virgin's Assumption into Heaven, or her Coronation, both of which episodes express the fact that the Virgin is supremely honoured because of her identity as mother of Christ. Some Books of Hours may use a Passion Cycle to illustrate the Office of the Virgin, which expresses the Virgin's importance in a different way, stemming from the idea that the Virgin's motherhood of Christ enables him to be born, in order that he should die to redeem humanity. Other books may combine Marian and christological illustrations. A typical cycle of illustrations focused on the Virgin might feature: the Annunciation; the Visitation of Mary to her cousin Elizabeth; the Nativity of Christ; the Annunciation to the Shepherds (and/or their visit to the manger); the Adoration of the Magi; the Presentation of Christ in the Temple; the Flight into Egypt; the Coronation of the Virgin. The equivalent christological cycle might begin with the Betrayal of Christ, and proceed through Christ's Appearance before Pilate, the Flagellation, Christ Carrying the Cross, the Nailing to the Cross, the Crucifixion, the Deposition, and the Entombment. The first hour of the Daily Office, Matins, is often the most lavishly decorated, and even where none of the rest of the cycle of the hours is embellished with images, it is usual for Matins to carry an illustration, usually the Annunciation. Therefore the Annunciation often forms the 'frontispiece' to the Hours of the Virgin, and is probably the most common image in Books of Hours.

An opening of an early 14th-century Book of Hours (Fig. 6) produced for the French Queen, Jeanne d'Evreux, by the Parisian workshop of the celebrated miniaturist Jean Pucelle, shows how Marian and Christological cycles of imagery might be combined. Folios 15 verso and 16 recto show the beginning of the Hours of the Virgin, with a miniature of the Annunciation that has many of the same elements that we have already noted: the Virgin is in an interior, into which the angel has entered. Though the Virgin stands, there is an indication that she may have been reading, as she holds a book, now closed, in her right hand. A vase stands on the floor between the angel and the Virgin, and the angel kneels and

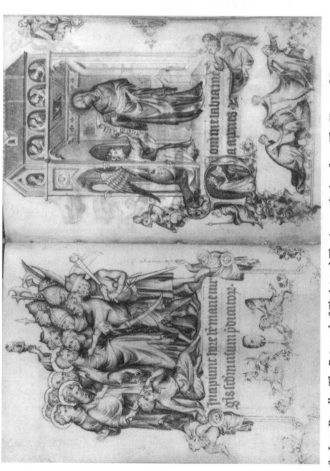

6. Jean Pucelle, *The Betrayal of Christ* and *The Annunciation*, from *The Hours of Jeanne d'Evreux*, New York, Metropolitan Museum, Cloisters Collection, MS. 54.1.2, fos. 15ᵛ and 16ʳ, c. 1325

addresses the Virgin. The beginning of his speech 'Ave Maria' (Hail Mary) is inscribed upon the curling scroll that unfolds from his left hand. Music-making angels surround the scene, and more angels offer prayers in the gables of the building. On the opposite page, Christ's Betrayal appears above the rubric that indicates 'Here begins the Hours of the Blessed Virgin Mary'. In a visual conceit that is very particular to Pucelle, angels support the building in which the Annunciation takes place, so that the pictorial space becomes ambiguous. The scene of the Betrayal opposite also appears to be supported by the figures beneath it. Pucelle has made one foot of a figure on either side of the Betrayal scene rest upon the head and shoulders of these supporting figures. The miniatures throughout this manuscript are executed in grisaille, with only slight touches of colour, and with some coloured backgrounds to the narrative scenes. The marginal images below the main illustrations show rather incongruous scenes of groups of people playing games. There is much discussion as to what these marginal scenes, common in many medieval manuscripts, can be intended to mean. Scholars differ on whether to interpret them as commentaries upon the main illustrations or texts or as mere decoration or visual diversions.

The text of the Hours of the Virgin opens with the phrase 'Domine labia mea aperies' (O Lord, open thou my lips). Each hour has a standard opening phrase, and these are known as the *incipits* of each hour, from the Latin 'incipere', to begin. The incipit of every hour other than Matins is 'Deus me in adiutorium meum intende' (O God make speed to help me). Each hour thus begins with a capital D, and that D is very often decorated or 'historiated'. In the Hours of Jeanne d'Evreux, the opening D of Matins, beneath the Annunciation, contains an image of the owner of the book, Jeanne d'Evreux herself, kneeling at her prie-dieu, with her prayer book open. An image such as this was designed to induce in the book's user the right frame of mind for prayer by showing her ready to begin meditating upon the sacred mysteries presented to her in the texts and images that will follow.

The Immaculate Conception

So far we have considered in detail one image of the Virgin – the Annunciation – that was derived from the biblical narrative of Luke's Gospel. This image could be used as an isolated narrative, expressing one or other of the different moments within the whole episode, or could be used as part of a larger narrative cycle. It could also be used to express something about the Virgin's identity as mother of God, or about her state of mind. By comparison, an image that concentrates specifically on a personal aspect of the Virgin, and which *does not* depend on a biblical narrative at all, is the Immaculate Conception. The idea of the Immaculate Conception of the Virgin was one that began in the eastern church, and then spread to the west, being mentioned in the liturgies of the English dioceses of Winchester and Canterbury from about the 11th century, and of Lyons and other French dioceses from the early 12th century. This concept has nothing to do with the conception and birth of Christ, although the Immaculate Conception of the Virgin and the Virgin Birth of Christ are sometimes confused. The idea behind the doctrine of the Immaculate Conception is that the Virgin was always sinless, that she had been conceived and born sinlessly. It was generally agreed that the Virgin led a pure and sinless life, but controversy raged around the exact nature of her conception. The church's doctrine was that every human being was conceived in sin, because of the sin inherent in sexual intercourse. Therefore all humans were subject to what the church called *original sin*, which was only removed after birth, by baptism. Some theologians argued that in order for Christ to have been truly divine and free of original sin, there cannot have been any stain of sin attaching to his mother. Therefore the Virgin had to have been conceived immaculately, without sin, also. Others opposed this, arguing that only Christ was conceived completely miraculously and without sin. For several hundred years the idea and the image of the Immaculate Conception were at the centre of a polemical debate between different parties within the church. Eventually, in 1854, the idea of the Virgin's Immaculate Conception was declared *dogma* – official

doctrine – of the Roman Catholic Church and within that branch of Christianity, at least, the matter was no longer open to debate.

One place where the doctrine of the Immaculate Conception of the Virgin was particularly strongly supported during the period of greatest controversy was Spain, where the monarchy had supported the idea since the 14th century. Artists attempted to represent the doctrine symbolically in several ways, with images of the chaste embrace of the Virgin's parents, and with other images designed to express the Virgin's purity. However, the type of composition that eventually became established as the definitive iconography is represented by a painting of the *Virgin of the Immaculate Conception*, now in the National Gallery in London. The Spanish painter Diego Velázquez (1599–1660) painted this image for a convent of Carmelites in his home city of Seville around 1618 (Fig. 7). The Virgin is shown as a young girl, standing on the moon, with a halo of stars around her head. This image recalls the Apocalyptic Woman in the Book of Revelation: 'And there appeared a great wonder in heaven: a woman clothed with the sun, and the moon under her feet, and upon her head a crown of twelve stars' (Revelation 12: 1). The Apocalyptic Woman had long been associated with the Virgin, and was variously adapted to represent the Virgin in several aspects, including the Virgin as Queen of Heaven and the Virgin of the Assumption, as well as the Immaculate Conception (see also Chapters 3 and 4). Velázquez made sure that the viewers of his painting would instantly have associated the Virgin in this painting with the Woman of the Apocalypse by creating a companion piece, a separate canvas showing St John, the author of the Apocalypse text, receiving his spiritual vision of the Woman of the Apocalypse in the heavens and writing it down. (This companion painting of St John is also in the National Gallery in London.) Velázquez's *Virgin of the Immaculate Conception* is not only based upon the Book of Revelation, however. To indicate the Virgin's immaculate nature the painter included, beneath her, several objects or images that were traditionally regarded as symbols of the Virgin's purity, including a fountain and

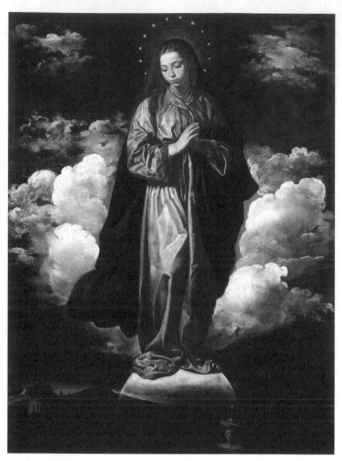

7. **Diego Velázquez,** *Virgin of the Immaculate Conception*, **London, National Gallery,** *c.* **1618**

an enclosed garden. These symbols are derived from the text of the Song of Songs, or the Song of Solomon, in the Old Testament. This text deals with a dialogue between a pair of lovers, a Bridegroom and a Bride, which has been interpreted in many ways in Christian biblical scholarship. Despite the erotic nature of much of the text, the words spoken about the Bride have been interpreted as

prophecies of the Virgin Mary's purity. In particular, one phrase spoken by the Bridegroom was especially fruitful for promoters of the Virgin's immaculacy: 'Thou art all beautiful my love / and there is no stain in thee' (Tota pulchra es amica mea / et macula non est in te – Songs 4: 7). It is clear from the Latin given here that this phrase, *macula non est in te*, seemed to offer a biblical basis for the idea that the Virgin was im-maculate, without stain of sin.

In 1649 Francisco Pacheco (d. 1654), Velázquez's teacher and father-in-law, gave detailed instructions for the correct way to depict the Virgin of the Immaculate Conception in his *Arte de le pintura* (Art of Painting). However, by this time, the composition was in fact fully developed and established, and Pacheco only codified the type as it had already been developing from the end of the 16th century and through the first half of the 17th century. Pacheco himself had already produced paintings of the Immaculate Conception that followed the same conventions as Velázquez's painting, as had other Spanish painters such as Francisco de Zurbarán (e.g. Barcelona, Museu Nacional d'Art de Catalunya, and Edinburgh, National Gallery of Scotland, 1630s) and also non-Spanish painters favoured by Spanish patrons, such as Peter Paul Rubens (e.g. Madrid, Museo del Prado, 1628–9).

Because the idea and the image of the Immaculate Conception was supported so vigorously in Spain, it became popular also in Spanish South America, having been promoted by the Franciscan and Jesuit Orders as part of their missionary activity there. The image of the Immaculate Conception became particularly widespread in South America from the mid-17th century, as a result of the Catholic church's promotion of the cult of the Virgin of Guadalupe. According to legend, the Virgin had appeared to a recently-converted Christian named Juan Diego (called Cuauhtlatoatzin before his baptism), in 1531, in the mountains near Tepeyac, north-west of Mexico City. Records of these visions tell how an image of the Virgin as the Immaculate Conception was miraculously imprinted upon Juan Diego's cloak. This image,

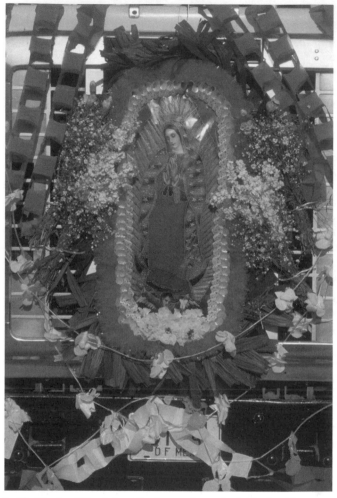

8. *The Virgin of Guadalupe* (festive car decoration), Mexico City, 1989

preserved today in the Basilica of Guadalupe in Mexico City, became the centre of the cult of Our Lady of Guadalupe. The Virgin of Guadalupe, as she appears in the revered image in the basilica, and in the countless copies and versions of that image, appears without the Christ-child, with her hands clasped together in prayer, dressed in a blue mantle covered with stars, standing upon the crescent moon, supported by an angel, and surrounded by a sunburst or mandorla.

Although Juan Diego's visions were supposed to have taken place in 1531, the first official inquiries into them, and the first written accounts of the events, emerged only in the mid-17th century. And although the image preserved in the basilica was supposed to have been created as a result of the 1531 visions, there is no record of the image before the early 17th century, when the first copies of it were made. Given the popularity of the image of the Immaculate Conception in 16th- and 17th-century Spain, it is interesting to note that the image of the Virgin of Guadalupe replicates the form of the Spanish images produced at the end of the 16th and early 17th centuries by Pachecho, Velázquez, and Zurbarán.

Whatever the status and the date of the original cult image preserved in the Basilica of Guadalupe in Mexico, the Virgin of Guadalupe became, and remains, a fantastically popular image in South America, and in Catholic communities of Spanish and Latin American origin throughout the United States and beyond. The Virgin of Guadalupe was proclaimed patroness of Mexico in 1754 and patroness of all the Americas in 1910, and thus enjoys special devotion among the Catholic populace of North and South America. The American national Roman Catholic shrine in Washington, DC, is dedicated to the Virgin of the Immaculate Conception, and images of the Virgin of Guadalupe are reproduced in souvenirs from the Mexican shrine of Guadalupe itself, and in countless postcards, medals, statues, candles, and other such images (Fig. 8). They are among the most reproduced examples of contemporary Christian imagery in North and South America today.

Chapter 2
The body of Christ

Faith in the birth of Jesus, and in his life and death, lies at the very roots of Christianity. Therefore images that illustrate Christ's life on earth, as a human being, are fundamental to Christian art. Christ is represented as a teacher and preacher, a leader, a healer, a judge, as well as a new-born baby and as a dead man. Artistic representations also go beyond his death, to show his resurrection, and his post-resurrection apparitions to his followers, as detailed in the Gospels. However, the textual sources focus more heavily on some areas and events in Christ's life than on others. Jaroslav Pelikan has pointed out that the Gospels give us information about fewer than 100 days in Christ's life, but that for the last few days of his life they provide 'a detailed, almost hour-by-hour scenario'. The account of Christ's death itself – the hours on the cross on Good Friday – forms the climax of the Gospel narrative, and images relating to the Crucifixion are among the most pervasive in Christian art. The Crucifixion is of course, the end of Christ's earthly human life, but it was also the ultimate purpose of his life. According to Christian doctrine, human salvation is achieved by Christ's death on the cross, which expiates the sins of humankind. Therefore the very essence of Christian belief revolves around his death, and his incarnation as a human being, which allowed him to suffer a human death. For this reason a focus on images of Christ's dying and dead body is crucial to an understanding of Christian art.

As already mentioned, in the previous chapter, images of Christ with his mother confirmed the identity of the Virgin as Mother of God, but also reminded viewers of Christ's incarnation, his taking of human flesh, which was the beginning of Christ's mission of salvation. Already inherent in Christ's birth was his death, and this is clear in many images of the Virgin and Child. The 13th-century panel by the Clarisse Master (Fig. 4), already encountered in Chapter 1, illustrates the significance of Christ's incarnation and death by its combination of events from the beginning and the end of the narrative of Christ's earthly life. By presenting these images together this painting represents the full cycle of Christ's redemption of humankind, and offers a compendium of ideas and images upon which the viewer could meditate. As we have seen, in the main field of the painting is an image of the Virgin and Child, probably inspired in its composition and style by Byzantine icons. Either side of the Virgin and Child are, on the left, the Angel Gabriel, and on the right the Virgin of the Annunciation, giving, as it were, a 'flashback' to the Annunciation, the very moment of Christ's incarnation, the beginning of his mission, and therefore the beginning of human salvation. Above the Virgin and Child, in the lunette-shaped field at the top of the panel is an image of the Crucified Christ, balancing the Incarnate Christ below. Above the Crucifixion, in the triangular spandrels in the top corners of the panel, two angels blow trumpets to left and right, announcing the Last Judgement, and beneath them two groups of human beings arise from their tombs. In this allusion to the Last Judgement we do not see Christ the Judge, as we might in other, fuller representations of the subject. (It may be that an additional figure of Christ as the Judge, or the Blessing Redeemer, was originally present in a now-lost gable from the very top of the panel.) As the painting stands at present, however, the combination of images still works visually, because the manner of composition and the precise way in which the Crucifixion and the Last Judgement are juxtaposed makes the connection between the two very obvious: the salvation of human beings is seen as a very direct result of Christ's Crucifixion.

The Clarisse Master's image of the Crucifixion includes various persons whom the Gospel accounts mention as present at the event. On the right we see St John the Apostle, to whom Christ was supposed to have been especially close, and to whom he entrusted the care of his own mother after his death (John 19: 26). Also represented on the right are figures of Roman soldiers, including the centurion who was converted when he recognized Christ's identity as the Son of God (Mark 15: 39; see also Luke 23: 47). On the left we see the Virgin Mary with two female companions, her own sister, Mary Cleophas, and Mary Magdalen (John 19: 25). The Magdalen is dressed in her customary red, and the Virgin in the centre is also recognizable by her clothing: a blue mantle over a pink undergarment, as in the image of the Annunciation and in that of the Virgin and Child below. Christ himself is shown in the manner that had become traditional by the mid-13th century: eyes closed, head resting on his shoulder, body curving out to one side. Earlier images of the Crucifixion had shown Christ alive, with his eyes open, and his body straight and supported, in a manner designed to show his triumph over death. Those earlier images are known as the *Christus Triumphans* (triumphant Christ). The representation we see in this small Italian panel is known as the *Christus Patiens* (suffering Christ) and this type of image places more emphasis on Christ's human suffering than on his triumph over death. As Christ's humanity and suffering became more central to Christian devotion so too did that of his mother. The Virgin Mary swoons at her son's death, and is supported by the other two Marys. The collapse of the Virgin visually echoes the collapse in death of her son, and indicates the idea of Mary's compassion, her suffering with Christ. The relationship of suffering between mother and son here in the Crucifixion is juxtaposed with the similarly close relationship illustrated in the Virgin and Child image below. Devotees of the Virgin Mary regarded her motherhood of Christ, and her fellow suffering with him at the Crucifixion, as having given her the authority and the capacity to intercede with Christ, to ask for mercy on their behalf. This was one of the reasons why the Virgin was so highly regarded as an intercessor, an advocate for sinners.

A further aspect of the developing medieval interest in Christ's humanity, and his human suffering and death, was a greater concern with the corporeal reality of his body and the wounds inflicted during the Passion. One of the most dramatic representations of the suffering body of the Crucified Christ is that on the exterior of the Isenheim altarpiece, by the German painter Matthias Grünewald (Fig. 9). This altarpiece was made for the chapel of a hospital run by the Canons Regular of St Anthony in Isenheim. Its construction took place in two stages. First the canons commissioned the Strasbourg sculptor Nikolaus of Hagnau to produce a carved altar depicting figures of interest to the monastic community – St Augustine, St Anthony, and St Jerome – with Christ and the twelve Apostles beneath. Then, a few years later, about 1510, Grünewald was commissioned to create two sets of painted wings for this altar, which could be opened or closed to reveal the altarpiece in three different states (Diagram I).

On the exterior of the outermost set of movable wings was depicted the Crucifixion, and it was this image that was probably most often visible on the altar of the monastery church at Isenheim. The artist has depicted the body of the Crucified Christ in such a way as to bring home the reality of his torture and suffering. His body hangs low, his arms having been torn from their joints. His legs are twisted, and the nails through his feet and hands are painfully obvious. As well as the large wound in his side, where the centurion pierced him with a lance, to see that his death was complete (John 19: 33–4) Christ's body bears numerous scars, apparently inflicted by thorns, and several thorns still remain embedded in his flesh. The loincloth is ripped and shredded, and the crown of thorns is shown as a real instrument of torture, with its sharp points lodged in Christ's head and face, and digging into his shoulder and chest. Beneath the Crucifixion, in a separate predella panel, we see the Lamentation over the dead body of Christ. The crown of thorns has been removed, and St John carefully lays out Christ's limp body on the shroud, prior to placing him in the tomb.

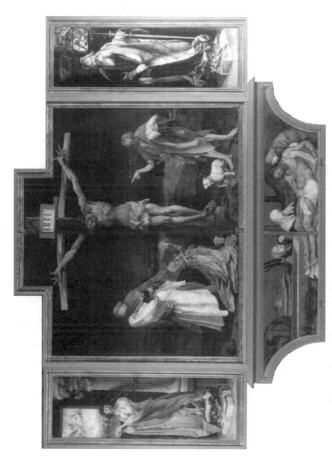

9. Matthias Grünewald, *Isenheim Altarpiece*, Colmar, Unterlinden Museum, c. 1510

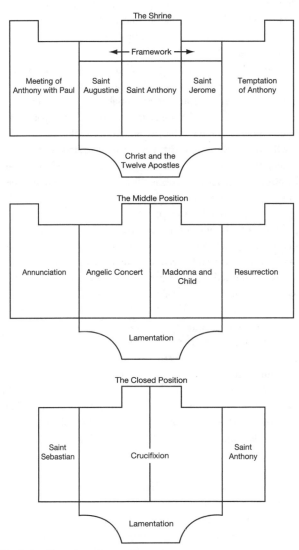

The Shrine

| Meeting of Anthony with Paul | Saint Augustine | Saint Anthony | Saint Jerome | Temptation of Anthony |

Framework

Christ and the Twelve Apostles

The Middle Position

| Annunciation | Angelic Concert | Madonna and Child | Resurrection |

Lamentation

The Closed Position

| Saint Sebastian | Crucifixion | Saint Anthony |

Lamentation

I. *Isenheim Altarpiece*, three states.

The small bloody wounds that appear all over Christ's body gain an extra dimension when seen in conjunction with the saints in the wings either side of the Crucifixion, and in the context of the altarpiece's original hospital location. In the left wing is St Sebastian, pierced through with the arrows with which he was tortured (prior to his eventual martyrdom by beheading). Sebastian was one of several 'plague saints' who were regarded as having the power to protect against the plague. In Sebastian's case, this association derived from the idea that the sores that appeared upon the skin of a person afflicted by the plague were like the wounds of arrows. St Anthony, in the right wing, was the patron of the monastery and its hospital, and was generally invoked as a healer. But he also had a particular connection with a plague-like disease, which went by the name of 'the infernal fire', or 'St Anthony's Fire', and the symptoms of which included inflamed boils and gangrenous wounds on the skin. The patients at Isenheim were presumably intended to take comfort in the presence of the two saints who were believed to have the power to protect against, or cure, these dreadful diseases. But viewers were also intended to appreciate a further message of spiritual redemption beyond physical death. They should not fear the pain and disfigurement connected with physical disease, because Christ's unimaginably painful death, held up to view here, had secured for them the promise of redemption and resurrection after whatever earthly death a mortal might suffer. The ravaged skin of Christ could be interpreted as showing the Isenheim patients that he bears all their suffering and sickness himself, not only the physical pain of their illnesses, but also the 'sickness' of their sin, potentially much more serious and damaging, and yet relieved in its damning effects by Christ's sacrifice.

The attendant figures in the Isenheim Crucifixion are depicted differently from those in the Clarisse Master's Italian panel. The number of figures has been reduced, and this time Christ's mother is supported in her grief and *compassio* not by the two Marys, but by St John. Her eyes are closed, and her pale face, drained of colour

by her suffering, is echoed by her white – rather than blue – mantle. Beneath the cross, Mary Magdalen (identifiable this time by her pot of ointment – see Chapter 3 – as well as by her red garment) wrings her hands in despair. In the predella, where the three figures carry out the Lamentation over the body of Christ, the mood is quieter, with all three figures appearing drained by their experience. The one additional figure not mentioned so far is John the Baptist, who stands to the right of the Crucified Christ. We know that this is John the Baptist for a number of reasons, including his physical appearance. He is shown as a hermit, with bare feet, and animal skins for clothing. The book that he holds is a common identifying attribute of a prophet, and identifies John as the last of the Old Testament prophets, who heralded Christ's coming. The Baptist's pointing gesture draws attention to Christ and indicates that the words inscribed on the panel, spoken by John, refer to Christ: 'He must increase, but I must decrease'. These words, from the Gospel of John (3: 30), have been interpreted in different ways, but seem to indicate that we are to be aware that the Crucifixion is the middle point between the era of the Old Testament, represented by John the Baptist, and the New Testament, represented by Christ. The Crucifixion is thus literally the crux of the two ages, after which humankind lives in a state of grace and is redeemed (see also Chapters 4 and 5).

Since the Baptist was already dead by the time Christ was crucified, and could not therefore have been present at the Crucifixion, his presence in this image is a departure from the historical narrative, and must serve a symbolic rather than a merely representative function. This is further indicated by the lamb at his feet. John the Baptist had described Christ as 'the Lamb of God, who takes away the sins of the world' (John 1: 29). The lamb here holds a cross, to make it plain that this creature is a symbolic reference to Christ himself. At the lamb's feet is a chalice, which receives blood from a wound in the lamb's chest. Since we know that Christ is the Lamb of God, it is clear that the blood pouring into the chalice must actually be the blood of Christ. This detail makes an explicit link

between the Crucifixion, the original sacrifice of Christ's body for the sins of humankind, and the liturgical service of the eucharist, which re-enacts or recreates that sacrifice continually at the very altar table upon which this image of the Crucifixion was originally placed.

Fascination with Christ's humanity, his body, and his human suffering and death, went hand-in-hand with a fascinated devotion to his body and blood in the eucharist. In 1215 the church had confirmed the doctrine of transubstantiation, which held that, by the action of the priest's consecration or blessing during the mass, the bread and wine of the eucharist were transformed physically and entirely into Christ's flesh and blood, but without any change in their visual appearance. At the Last Supper, the night before Christ's Crucifixion, Christ had blessed and distributed bread and wine with the words 'This is my body' and 'This is my blood'. The doctrine of transubstantiation held that he had intended it to be understood that when his followers obeyed his instruction to 'Do this in memory of me', and blessed bread and wine in the future, the materials thus consecrated would be literally transformed into his body and blood (Matthew 26: 26–8; Mark 14: 22–5; Luke 22: 19–20). From 1215 until the early 16th century the doctrine of transubstantiation was the officially accepted position of the universal Christian church. With the Protestant Reformation (see Chapter 5), different Christian denominations developed various understandings of the precise status of the eucharist. These different positions could be plotted along a continuum, from the idea that during the mass the consecrated bread and wine became truly and absolutely Christ's body and blood (as maintained by Roman Catholics) to the idea that the service of the eucharist was simply a commemoration of Christ's actions at the Last Supper (as understood by the more radical Protestant tradition). But at the time of the conception of the Isenheim altarpiece, transubstantiation was still the official doctrine of the church. This altarpiece, therefore, functioned as the backdrop to services of the eucharist in which the bread and

wine were believed to be transformed into the body and blood of Christ. It was understood that the priest's repetition of Christ's words of blessing effected the transformation, and the consecrated bread and wine were then lifted up by the priest for the congregation to see. If the altarpiece was completely closed, the congregation at Isenheim would have seen the elevated bread and wine against the background of two images of the dead Christ: in the Crucifixion, and also in the Lamentation in the predella below. Even in the altarpiece's half-open state, with the Annunciation, Nativity, and Resurrection images visible, the Lamentation remained visible below as a backdrop to the ceremony of the eucharist.

The precise composition of the Lamentation here, with St John supporting Christ's body under the shoulders, has the effect of displaying Christ's torso to view, and allowing the viewer to see the bloody wound in his side. This meant that the narrative image of the preparation of Christ's body for the tomb could also operate here as a focus for devotion and meditation on the body of Christ and on the wounds of his Passion. An artistic process of abstracting and adapting narrative images of Christ's Passion into images for devotion had begun to develop in the two centuries before the Isenheim altarpiece. One of the most popular of these devotional images was known as the 'Imago Pietatis', the 'Image of Pity', or the 'Man of Sorrows'. This composition isolates the Crucified Christ, and offers his dead, wounded body to view. The Man of Sorrows is usually depicted half-length, sometimes standing in the tomb, sometimes standing against the cross. The body is sometimes supported by angels, sometimes alone, usually with closed eyes, and with his hands folded on his breast, so that the wounds in his hands and side are clearly visible.

A 14th-century diptych painted in Bohemia pairs the image of the Virgin and Child on the left with the Man of Sorrows on the right (Fig. 10). As in the Clarisse Master's Umbrian panel, the Christ-child here presses his face close to his mother's in a variant of

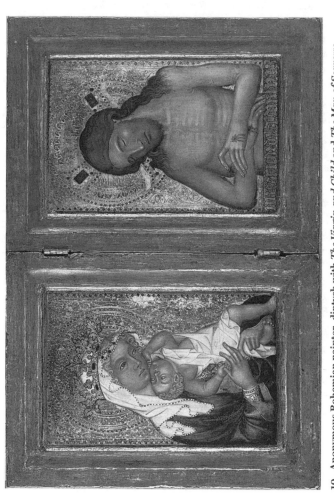

10. Anonymous Bohemian painter, diptych with *The Virgin and Child* and *The Man of Sorrows*, Karlsruhe, Kunsthalle, c. 1350

a Byzantine icon-type. In the other panel, the half-length Crucified Christ, his eyes closed and head dropped to the side, displays the wounds in his hands to the viewer's gaze. Curiously, though, the dead Christ's hands are in some senses active, or demonstrative. The index finger of Christ's left hand is raised, and directly points out the wound in his side, as if inviting the viewer to contemplate that specific element of the image. (The side wound was often accorded special prominence, as it was close to Christ's heart, and was sometimes portrayed in isolation, as an object of contemplation in its own right. This later developed into the symbolic image of the 'Sacred Heart' of Jesus.) The fingers of Christ's other hand rest upon the painted inscription underneath, pointing to the words 'misericordia domini' (the mercy of the Lord). This indicates that the viewer is intended to understand the Crucifixion, the sacrifice of Christ, as proof of God's compassion, grace, and mercy towards humankind.

The image of the Man of Sorrows was linked with a vision supposedly experienced by the 6th-century pope Gregory the Great (see also Chapter 4) while celebrating mass one day in Rome. As Gregory consecrated the bread and wine, it was related, Christ appeared to him above the altar. This apparition lent eloquent support to the doctrine of the 'Real Presence' of Christ's body in the eucharist, since Christ himself, in bodily form, was manifested on the altar at the moment when the bread and wine were supposed to become Christ's body and blood. To commemorate the event, the Pope ordered an image of Christ to be made according to his exact appearance in this vision. A mosaic image, preserved at the church of Santa Croce in Gerusalemme, Rome, was, in the later Middle Ages, regarded as the original image that Gregory had had made (and was strongly promoted as such by the Carthusian monks who were in charge of the church in which it was housed) even though it actually dates from the 12th or 13th century. In the 15th century the monks of Santa Croce asked the German engraver Israhel van Meckenem, the best-known printmaker of his day, to make

11. Israhel van Meckenem, *Mass of St Gregory*, London, British Museum, 1490s

engravings of their mosaic icon, and of the miracle event of the mass of St Gregory. These reproductions were bought in great number by members of the faithful, partly because the Man of Sorrows image was promoted enthusiastically by the wider church, not just by the monks at Santa Croce. Indulgences were pledged by the church to those who prayed in front of certain images. In the case of the Man of Sorrows, indulgences – of 20,000 years of pardon from punishment in purgatory – were attached not just to the Roman original, but also to copies of it, and to the associated image of the mass of St Gregory. All later images of the Man of Sorrows (which proliferated in the West from the 13th and 14th centuries) were regarded as 'copies' of Gregory's original. (In fact, the legend of Gregory's vision probably developed *after* such images, as a means to explain them.)

The engraving now in the British Museum in London shows the half-length Man of Sorrows appearing out of the tomb on the altar as the consecration takes place (Fig. 11). It reproduces what were clearly thought to be the salient iconographic features of the original mosaic icon: the arrangement of Christ's body against the cross; the position of the head, dropped to one side; the flowing locks of hair on the shoulders; the closed eyes; the visible wounds in the hands and side. These features are the same in our Bohemian diptych (Fig. 10), which indicates that it too was probably in some senses regarded as a 'copy' of an 'authentic' original.

The Man of Sorrows image clearly had a special and particular status because it was regarded as a 'true likeness' of Christ, a record of his death at the Crucifixion, and a proof of the Real Presence of Christ's body and blood in the eucharist. These aspects of the image account for the many, many copies and versions of the image of the Man of Sorrows, produced in many different regions, in different media, for different patrons, and for different purposes. The image was, like the Books of Hours examined in the previous chapter, another 'best-seller' of its time.

Chapter 3
The saints

The practice of venerating the saints – individuals recognized as especially virtuous and holy – has been of critical importance in Christian worship from the beginning. (The term 'saint' comes from the Latin term 'sanctus' – 'sancta' in the feminine – meaning 'holy' or 'consecrated'. In the East, the equivalent Greek term 'hagios' – or 'hagia' – is used.) A great deal of Christian art features representations of these revered persons, from the early saints, including Jesus Christ's own companions, such as St Peter, down to medieval saints such as St Francis of Assisi (d. 1226). The Roman Catholic church continues to recognize individuals as saints, and images of modern saints are still produced, and can be found in Catholic churches and homes throughout the world. For example, images of Padre Pio, an Italian Capuchin monk who died in 1968, and who was canonized (officially recognized as a saint) in 2002, are extremely widespread and popular, especially in Italy and America.

In the early church no formal mechanism existed for consecrating or differentiating those among the Christian dead who were officially recognized saints. The mechanism for formal canonization only developed during the later Middle Ages (see below). Nevertheless certain individuals attracted particular reverence, especially the Apostles, who were Christ's earliest followers, and the martyrs, those who had died for their faith. By being prepared to

die for his or her Christian beliefs a martyr was regarded as having offered the ultimate witness to the truth of Christ's teachings and his death and resurrection. (The term 'martyr' comes from the Greek 'martus' meaning 'witness'.) The saints and martyrs were honoured by the whole Christian community coming together at their tombs, and sharing a eucharistic meal, on the anniversaries of their deaths. The burial place thus became the centre of devotion to the saint, and the day of death became the particular day of commemoration. In the early Christian period, the cult of saints was, therefore, focused geographically upon the place where the remains, or relics, of the saints were buried, and the relics were venerated as objects endowed with particular spiritual potency. It was believed that physical proximity to the relics of the saints had beneficial effects, and people went on pilgrimages to saints' shrines in the hope of achieving a benefit, often the healing of an illness or a disability. Because of this devotional need to visit the place of burial and to come as close as possible to the actual shrine, or container, in which the body of the saint was contained, the term 'shrine' has also come to be understood, in general usage, as a place at which a saint is venerated. Relics were often kept in precious, metalwork containers, adorned with sculpted figures or decoration, jewels, and enamels. Shrines for full-body relics were often gabled in shape, like small buildings, with pointed roofs. In England, and in other areas that experienced iconoclasm during the 16th-century Reformation and after (see Chapter 5), saints' tombs and shrines were destroyed, and the precious metalwork melted down, so that we have little direct material evidence about their appearance in these areas. But contemporary representations, such as that in a 13th-century Anglo-Norman manuscript of the Life of St Edward the Confessor (Fig. 12), seem to indicate that the form of English shrines was similar to surviving examples from elsewhere in Europe. This illustration shows pilgrims kneeling in prayer at the shrine of St Edward, the English king-saint who was buried in Westminster Abbey. A stone platform supports the shrine, which is itself apparently metalwork, with small sculpted figures, and decorative crockets and finials. A pilgrim is seen climbing into holes

12. *The Shrine of St Edward the Confessor* from *La Estoire de Seint Aedward Le Rei*, Cambridge, University Library, MS. Ee.3.59, fo. 30, c. 1255–60

in the shrine base upon which Edward's burial casket is raised, in order to achieve even greater closeness to the body of the saint.

Christian devotion to saints' relics stemmed in part from perceived physical benefits such as healing miracles. But devotion to the saints and their relics also derived from their perceived efficacy as intercessors: by manifesting their devotion to their chosen saint, pilgrims hoped to encourage the saint to offer prayers to God on their behalf, or on behalf of someone whom they wished to help.

The original association between the tombs of the martyrs and the eucharistic meals held at them by Christian communities meant that altars, as well as shrines, had always been associated with the bodies of the saints: churches came to be built as close to the burial places of saints as possible, and the altar was placed, if possible, over the tomb itself. The altar, and usually the church surrounding it, was then named and dedicated in honour of the saint. Later, as churches multiplied, and more altars were erected, it was not always possible to associate each altar with the tomb of a saint. In order to preserve the association between saints' relics and the eucharistic altar table it became the practice to place smaller relics within the body of the altar itself at the time of its consecration. Painted panels were produced to be placed on the altars dedicated to saints, or on tomb-altars, which, as the name would suggest, were combinations of a tomb with an associated altar. These painted images identified the saint whose cult was celebrated at that particular location, and stimulated devotion to the saint. Altarpieces of saints often combined a central image depicting the saint, usually full-length, either standing or enthroned, with scenes from his or her life, sometimes including representations of miracles that had been attributed to the saint. The Sienese painter Simone Martini painted a panel depicting St Louis of Toulouse, which is now in Naples (Fig. 13). The main image shows St Louis as a Franciscan bishop-saint, enthroned and crowned by angels, and crowning another man who is kneeling at the saint's feet. This other

man is Louis's younger brother, King Robert II Naples (Robert of Anjou), who received the crown of the Angevin royal house of Naples when Louis abdicated in order to become a Franciscan.

The panel includes in its predella (fourth scene from the left, Fig. 14) an image of the funeral of St Louis, which took place at the Franciscan church in Marseilles, in August 1297. The sanctity of St Louis is demonstrated by the fact that he has already begun to work miracles, as sick and crippled individuals are healed in proximity to his body. Two sick people, one crippled, one apparently in seizure or possessed, are contrasted with a standing pilgrim, who has presumably been cured by St Louis and points towards his body in recognition of that fact. This panel was probably intended to be associated with a shrine of St Louis, either at the original place of burial at Marseilles, or in Naples, to where Robert of Anjou had taken back Louis's brain as a relic. The image of the healing of the sick at Louis's funeral would presumably have encouraged pilgrims at Louis's shrine to believe in the power and efficacy of his relics, and to pray and leave offerings at his tomb. Churches with successful saints could expect to make a significant amount of money from the offerings left by visiting pilgrims. Therefore, candidates for the sainthood, like Louis of Toulouse, were enthusiastically promoted by the churches that housed their bodies, and by the religious communities from which they had come (the Franciscans in the case of Louis of Toulouse). Robert of Anjou himself was also very closely involved in the campaign to have Louis canonized, as the legitimacy of his own reign would have been greatly enhanced by Louis's canonization, and by the church's consequent implied sanction of Louis's decision to hand his throne over to his younger brother.

The Louis of Toulouse panel is usually dated after 1317, the year of Louis's canonization, and is most often regarded as a commemoration of that event, which was so important to Robert of Anjou. But it is equally possible that the panel was commissioned in anticipation of the canonization, as part of the effort that the

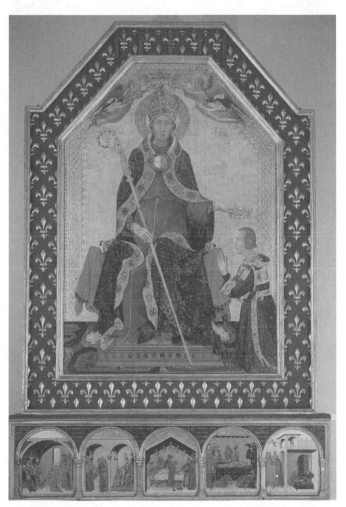

13. Simone Martini, *St Louis of Toulouse*, Naples, Museo Nazionale di Capodimonte, *c.* 1317

14. Simone Martini, *Funeral of St Louis*, predella of St Louis panel (**detail of Fig. 13**)

Franciscans and the Angevin royal family were making to achieve sainthood for Louis. By the 13th century the process of recognizing a saint had moved on from local acclaim and recognition of a person's holy life or miracles, as in the early Christian church, and the mechanism of canonization was increasingly coming under the control of the papacy. By the time of Louis of Toulouse's death, a rigorous legal process had been developed, to test the legitimacy of claims for canonization. A definitive version of the person's life had to be established, that demonstrated their holiness, and miracles

performed by the saint had to be verified. Artworks could help in this process, by making manifest the significant episodes of a potential saint's life, as do the predella scenes of the St Louis panel. These illustrate Louis's request to become a Franciscan, his entry into the Franciscan Order and his consecration as a bishop, as well as the healing miracle already mentioned, and, in the fifth image in the predella, another miracle concerning the resurrection of a sick or dead child. The precise subject of the central image in the predella is unidentified, but the whole ensemble of imagery is certainly dedicated to the identification and promotion of St Louis himself. His identity is made clear by a variety of means, including the particular representation of the saint in the central panel, the narrative predella illustrating key events in his life, and the fleur-de-lis heraldry on the frame of the panel, which was associated with the Angevin royal family. His sanctity is promoted by his representation with a halo, by the angels bestowing a heavenly crown upon him, and by the representation of his miracles.

The St Louis panel is connected with the veneration of an individual saint, at the location of his particular cult. But often saints appear in the company of other saints, in large altarpieces, for example, where their identity is not so easily gleaned from context, location, or specific physical appearance. In these cases, artists adopted a number of strategies for making clear the identification of the saints depicted. Sometimes, by tradition, a particular saint had come to be associated with a particular physical appearance, so that St Peter, for example, is almost always shown with white hair and a white beard, and usually wearing yellow. St Paul has dark hair and a dark beard, St Mary Magdalen has long, loose hair and wears a red dress, and so on. Sometimes this would be enough to give a clue as to which saint was which, if one happened to know that an image represented Sts Peter and Paul, for example. But if, as was common, an altarpiece contained representations of a number of different saints, some perhaps more obscure than others, artists had to adopt other strategies for identifying the individual figures. Sometimes individual saints were identified by textual inscriptions, and

sometimes their names were inscribed within their gold haloes. But where it was not practical to identify the figures with textual inscriptions, or where the viewers of these images could not all be expected to be able to read such inscriptions, other means of identification had to be devised.

The most common was to give each saint an 'attribute', an object specifically associated with that saint, which acted as a pictorial 'label'. Attributes might make reference to a significant event in a saint's life, or a particular achievement for which they were known. St Mary Magdalen, for example, often carries a small pot, with a lid, to recall the tradition that she washed the feet of Christ, wiped them with her own hair, and anointed them with costly ointment (Luke 8: 37–8). Very often saints' attributes were associated with the ways in which they had died, as in the case of St Stephen, the first martyr, who was stoned to death, and is thus usually shown with a stone on his head, or St Bartholomew, who was skinned alive, and thus carries a knife. These stories of martyrdom sometimes gave rise to traditions in which the saints became associated with particular groups of people, in ways that may seem, to the modern viewer, almost gruesome or even irreverent in their literalism: St Stephen was invoked as patron saint of those with headaches, and St Bartholomew was invoked as the patron saint of tanners and leatherworkers.

From the 14th century onwards, groups of saints, with their attributes, became a regular feature in Christian art. Large altarpieces were commonly produced in which a central panel showing the Virgin and Child, the Crucified Christ, the Coronation of the Virgin, or some such representation, was accompanied by two or more side panels populated by groups of saints, identified by their attributes. The *Altarpiece of St John the Baptist and St John the Evangelist*, painted by Hans Memling in 1479 for the chapel of the Hospital of St John in Bruges, offers several different examples of the use of saints' attributes for identification (Fig. 15). The central panel shows the Virgin and Child enthroned in the centre, attended

15. Hans Memling, *Altarpiece of St John the Baptist and St John the Evangelist* (open state), Bruges, Hospital of St John, 1479

by a group of saints, two male, standing in the rearground, and two female, seated or kneeling in the foreground. Such an arrangement of saints around the Virgin and Child is often known by the Italian term 'sacra conversazione'. Although the term can be translated into English literally as 'holy conversation', the figures are not usually shown talking to one another: they simply coexist within the same space. In fact, as Rona Goffen has pointed out, the older meaning of the term 'conversazione', as used in the period when such paintings began to be created, is 'community', and therefore we can think of these paintings as representing a 'holy community'. The two female saints in the foreground are virgin martyrs, both of whose cults are of uncertain origin, and who often appear together in arrangements like this. On the right is St Barbara, who was alleged to have been killed in the Emperor Maximian's campaign of persecution against Christians (c. 303). The *Golden Legend* tells the story of how her father shut her up in a tower so that no man should see her, and the tower thus became her attribute. In this altarpiece a small, elaborately conceived architectural structure containing a tower is placed on the floor behind the saint. In other representations she holds a small tower in her hands. Her absorption in a book probably makes reference to her decision to live as a hermit after her conversion to Christianity. This conversion was unwelcome to her father, and he handed her over to be condemned to death. Unfortunately for him, the father met an untimely death, as he was struck by lightning, and died. In what might seem a slightly strange leap of association, St Barbara herself came to be invoked as a protector against sudden death. Barbara's equivalent on the left of the altarpiece's main panel is St Catherine of Alexandria, who wears a crown in accordance with the tradition that she was of noble birth. Like Barbara, she was supposed to have lived in the 4th century. She refused marriage to the Roman Emperor because of her Christianity, saying that she had given herself to Christ, as his bride. She was persecuted and tortured because of this, before her eventual martyrdom by beheading. This figure is identified as St Catherine in several ways. First, the Christ-child makes physical contact with her, placing a ring upon her finger. This makes reference to the saint's

description of herself as 'bride of Christ'. On the floor in front of the saint we see a sword, which makes reference to her martyrdom by beheading. A broken cartwheel on the carpet in front of Catherine acts as an additional identifying attribute. This refers to one of the tortures to which she was subjected, which involved being tied to a wheel so that her body would be broken upon it as the wheel turned. In fact, when Catherine's torturers attempted this, the wheel itself broke, as is indicated here by its incomplete state. Catherine's wheel gives its name to the spinning 'Catherine Wheel' firework, and is the most common attribute in representations of this saint (e.g. Raphael, *St Catherine*, London, National Gallery, *c.* 1507–08). Sts Barbara and Catherine were very often depicted together, and were generally invoked in times of adversity. However, they have some further relevance in the context of the hospital for which this altarpiece was produced. St Catherine, as the bride of Christ, is a model for the chaste monastic community, and St Barbara, as a protector against sudden death, would have been a comfort to mortally sick patients, who would have feared the prospect of dying without adequate preparation, and without the sacraments.

The two female saints are balanced by two male saints, who, as the common name of this altarpiece would suggest, are the two Sts John. The saint on the left points towards the Christ-child, and his attribute is a lamb standing beside him. This immediately identifies the saint as St John the Baptist (see Chapter 2). The saint on the right holds a chalice with a snake inside it. This object identifies the saint as the other St John, the Evangelist, the writer of the Fourth Gospel, and the saint who was often depicted as present at the Crucifixion (see Chapter 2). The chalice with the snake makes reference to a legend, from the apocryphal 'Acts of John', and related in the *Golden Legend*, in which a priest of the goddess Diana, at Ephesus, challenged John to drink a chalice of poison, as a test of his faith in Christ. John survived the ordeal unharmed. Although this legend came from an apocryphal source, it was as well-known as the Gospel account of St John the Baptist's reference to the Lamb of God, and the chalice would have served to identify St

John the Evangelist just as easily as the Lamb identified the Baptist. Like the figures of Catherine and Barbara, the two Sts John have a more specific relevance to the context in which they appear. Their attributes – the Lamb of God and the chalice – work on another level here, beyond their character as objects to identify the saints. They serve to recall the eucharist, which would have taken place on the altar in front of this painting. John's words 'This is the Lamb of God, who takes away the sins of the world' (John 1: 29), are spoken by the priest during the consecration, in the liturgical service of the mass. John the Evangelist performs a gesture of blessing over the chalice, as the priest would have done during the consecration of the wine. Thus these saints remind viewers of the efficacy of the eucharist, taking place on the altar in front of them, just as the body of the Crucified Christ and the Lamb of God with the chalice did in the Isenheim altarpiece's Crucifixion (Chapter 2).

Like the Isenheim altarpiece, Memling's St John altarpiece has wings, enabling it to be opened and closed. The interiors of the wings, on show when the altarpiece was open, contain additional narrative representations of the two Sts John, further emphasizing their importance as patrons of the hospital. On the left we see the beheading of St John the Baptist, and the placement of his head on a silver platter. On the occasion of King Herod's birthday feast, his wife's daughter Salome pleased the king with her dancing, and he offered her anything she wanted as a reward. She demanded the head of John the Baptist, on a plate, and John was duly executed. In the far background of the left wing we see the birthday feast taking place, with Salome's dance shown as a sort of 'prequel' to the action of the execution in the foreground. The narrative on the right wing concerns not the death of St John the Evangelist, but the visions of the Apocalypse that he received on the island of Patmos, towards the end of his life and which were recorded in the Book of the Apocalypse, or the Book of Revelation, the last book of the Bible. (We see John setting off for Patmos on his boat, after his torture and banishment in the background of the central panel, to the right of the standing figure of St John.) In the rainbow-mandorla in the

top left corner of the right wing an angel shows John the vision of God enthroned, with the Lamb, surrounded by the four beasts of the Apocalypse, and the Elders (Rev. 4). The four horsemen of the Apocalypse (Rev. 6: 1–8) ride across the centre of the panel. On the right of the wing, in the background, we see many of the events described in the middle chapters of Revelation, including the eclipse of the sun and the stars falling from the sky (Rev. 6: 12–13), hail and fire raining on the land (Rev. 8: 7), the burning mountain being hurled into the sea, destroying the ships (Rev. 8: 3–5), and a star falling into the rivers and springs (Rev. 8: 10). Above all this, in the sky, is the Woman of the Apocalypse (see also Chapter 4), threatened by the dragon which is defeated by St Michael (Rev. 12). Memling has thus incorporated an extraordinary amount of detail into this panel, relating many events from the text of Revelation with a high degree of faithfulness to the text. The visual narrative, so close to the text written by John, serves as another attribute of the saint, identifying his achievement as the visionary who made known the future events of the Apocalypse.

The representation of saints and their attributes continues onto the outside of the altarpiece. On the exterior surfaces of the wings, visible when the altarpiece was closed, are depicted the donors of the altarpiece, two monks and two nuns of the hospital, each accompanied by his or her patron saint. The saints are identified in the normal way, by their attributes, and are, from left to right: St James, with his pilgrim's staff and bag; St Anthony, dressed in his black monastic robes; St Agnes, carrying a lamb (a pun on the closeness of her name to the Latin for lamb, *agnus*); and St Clare, who wears the robes of the order of Poor Clares which she founded, and carries a monstrance containing the Blessed Sacrament. (This latter attribute recalls the account of the attempted sacking of the city of Assisi by the armies of Emperor Frederick II, which was supposed to have failed when Clare came to the walls of the city with a pyx containing the eucharist.) This quartet of saints on the outer wings is, like the saints within, identified by the appropriate garments or attributes. Therefore members of the community

would have been able to identify the saints, and would have been encouraged to offer prayers to them, hoping for their intercession and protection. But the saints here, sharing the name of the person with whom they stand, also act as attributes themselves, identifying the individual donors. It was common for people to be particularly devoted to the saint or saints who bore their own name, and to regard this saint as having a particular patronal or protective role. Therefore, viewers would have expected the person standing with St James to be called James, the person with St Anthony to be called Anthony, and so on. Thus, by consulting the records of the hospital from the relevant years, it is possible to work out that the quartet of donors is, from left to right, Jacob (James) de Ceuninc, Antheunis (Anthony) Seghers, Agnes Casembrood, and Clara van Hulsen. The four saints, with their commonly recognizable attributes, would have helped contemporary – and later – members of the hospital community to recognize and remember those individuals who had been responsible for the creation of the altarpiece, and would have encouraged them to offer prayers for these individuals, in thanks for their gift which was a benefit to the whole community.

This system of intercessory prayer came under attack during the 16th-century Reformation and in Protestant churches images of the saints tended to be replaced by images of Christ. Saints' shrines were destroyed, and the precious metalwork and jewelled shrine caskets were broken down for their raw materials. Therefore most images of the saints in European art after the 16th century are from the Roman Catholic tradition (see Chapter 5 for further detail). The Catholic church continued to promote the saints as worthy of devotional prayer, and as effective agents of intercession, as well as virtuous models to be followed and emulated. Patrons and donors of works of art continued to associate themselves with their name-saints. In Rome, in the late 16th century, a French cardinal named Mathieu Cointrel, remembered today by his Italianized name, Matteo Contarelli, endowed a chapel in the church of S. Luigi dei Francesi and arranged for the walls, altarpiece, and ceiling of the chapel to be painted with scenes from the life of St Matthew, his

patron saint. Contarelli died in 1585, having made preliminary arrangements for the decoration of the chapel, but with the project barely having been begun. Eventually, at the very end of the 1590s, the clergy at S. Luigi took responsibility for the completion of the chapel, and gave the commission for the painting to Michelangelo Merisi. This painter is now more commonly known as Caravaggio, having been known during his career as Michelangelo da Caravaggio, after his family's home town, 43 km east of Milan. Caravaggio was to paint the *Calling of St Matthew* for the left wall of the chapel, and the *Martyrdom of St Matthew* on the right wall, accompanied by an image of *St Matthew and the Angel* above the altar. The paintings for the two side walls were finished in 1600, and we will look at just one of these here, the *Martyrdom of St Matthew* (Fig. 16).

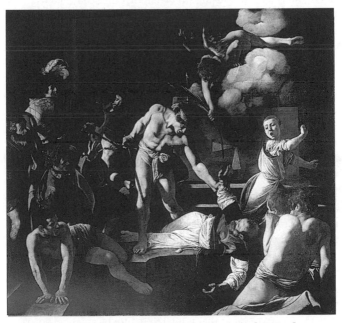

16. Caravaggio (Michelangelo Merisi), *Martyrdom of St Matthew*, Rome, S. Luigi dei Francesi, Contarelli chapel, 1600

This painting, on canvas, is a far larger work than anything Caravaggio had produced in his earlier career. This large scale, and the drama of the action and of the human emotion portrayed, is characteristic of the emerging style utilized during the Catholic Counter-Reformation. In the years following the Council of Trent (see Chapter 5) art produced for the Catholic church sought to arouse viewers' emotions, and to assault their senses with scale, drama, and action. Images of the saints focused often on their physical suffering or endurance during torture and martyrdom, in an effort to make clear, with a striking forcefulness, the implications of the saints' Christian witness. Caravaggio's *Martyrdom of St Matthew* uses a number of devices to heighten the tension, including dramatic action, varied responses in the onlookers, and dramatic lighting effects. Contarelli's original instructions for the painting stipulated that the scene had to integrate

a large number of all sorts of men, women and children, old, young and babies . . . for the most part, frightened by the event, creating contempt in some and compassion in others . . .

The *Golden Legend* stated that the saint had been murdered during his mission to Ethiopia, while celebrating mass, on the instruction of the heathen King Hirtacus. Although a stone altar, with its inlaid cross, and the steps up to the altar, are clearly indicated, the rest of the ecclesiastical structure is suggested only by a few shadowy columns on the left: the rest of the church has disappeared into the dark background which was, by this time, becoming characteristic of Caravaggio's paintings. The fall of light emphasizes the standing assassin in the centre, straddling the body of the saint who has been knocked to the ground by the force of the fatal blow he has received. Blood stains the saint's clothing, and we are alerted to the inevitability of Matthew's death by his reaching to grasp the martyr's palm that is offered to him by an angel hovering in clouds above the altar.

The assassin grabs St Matthew's wrist, making a physical connection between the two men, and creating a visual axis for the painting, around which a centrifugal composition unfurls. St Matthew's other arm, hanging beneath the step upon which he lies, and resting flat on the next level down, leads the viewer's eye to the left. The right leg of the man in the bottom left corner leads the eye left and upwards, and the glances and gestures of the figures in the crowd on the left continue the movement across, over and beyond the executioner, helped by the downwards curve of the martyr's palm, to the terrified child and the cringing youths on the right. These figures are cut off by the edges of the picture plane, suggesting that the centrifugal movement might continue outwards, perhaps encompassing the viewer, and this helps further to involve the viewer in the action of the painting. A full range of human emotions is conveyed by the different gestures, poses, and facial expressions of the onlookers, and this, again, helps to involve the viewer, not just informing him or her as to the salient events, but also suggesting the ways in which witnesses might have felt in experiencing those events at first hand. This is a rather different approach to a saint's martyrdom from that seen in Memling's depiction of the death of St John the Baptist, for example, where the martyrdom is not without violence, but does not seek to create the kinds of strong emotional reaction sought by the Catholic painters of the post-Reformation period. By the arousal of emotion, artists sought to enhance viewers' involvement in the religious narratives and to heighten their devotion to the saints depicted. This different approach to narrative was partly enabled by a different and more complex attitude to the potential of narrative painting itself, which developed during the later Middle Ages.

The saints

Chapter 4
Images and narrative

It is often said, in the context of Christian art, that images function as the 'books of the illiterate'. The origin and context of this view is not so often articulated, however. The saying arises with Pope Gregory the Great (590–604), the pope who received the vision of the Man of Sorrows during the mass (Chapter 2). In a letter to St Serenus, the bishop of Marseilles, Gregory expressed the view that 'What writing does for the literate, a picture does for the illiterate looking at it, because the ignorant see in it what they ought to do' and 'Painted likenesses [are] made for the instruction of the ignorant, so that they might understand the stories and so learn what occurred.'

According to Gregory images could fulfil a useful purpose, not only in stimulating religious feelings, but also in conveying the important messages of the scriptures to those who could not read them. What exactly did 'illiterate' mean in this context? It used to be assumed that the ordinary lay population in the earlier medieval period was almost totally illiterate, and that only the most educated of clerics had a decent knowledge of Latin. However, more recent scholarship has discerned more subtle gradations and levels of literacy, from a reasonable reading knowledge of the local vernacular, through an ability to read and write in the vernacular only, through the ability to read Latin, right up to the elites who could not only read and understand Latin, but write elegantly in it

as well. Some laypeople might have had a basic ability to understand some limited Latin, but might also have found pictures very helpful in reminding them, or guiding them, as to the meanings of the texts.

In any case, the view that images were helpful to those whose levels of literacy were not high enough to read the Latin scriptures unaided became a widespread justification for the decoration of church buildings with images, and Christian writers from the time of Gregory onwards reiterated this opinion. For example, the Venerable Bede, the 8th-century monk of the monastery of Wearmouth-Jarrow in the North of England, defended depictions of sacred stories for instructive as well as ornamental purposes, so that 'those who are not capable of reading words may learn the works of our Lord and Saviour by looking at these images'. However, in another sermon, Bede introduced a slightly different understanding of the effect of religious imagery when he remarked that pictures could 'recall to the memory of the faithful' events such as the Crucifixion, or other Christian miracles. This is an important distinction, as Bede appears to argue here that pictures can remind viewers of that which they already know, rather than teach them what they do not know, and what they cannot read in scripture. In other words, Bede's understanding of religious imagery here (and that of several other later writers) is that such pictures fulfil a recollective rather than an instructive function. Theologians of later periods considered these different functions, and gradually a position was arrived at whereby the church sanctioned and encouraged the use of images both to instruct and to remind. St Bonaventure (1221–74), the Minister General of the Franciscan Order, established a tripartite defence of religious art: that images were made for the uneducated, who may, through the images, understand that which they cannot read in scripture; that devotion is more likely to be aroused in those who see images of the deeds of Christ than in those who merely hear about them; and that those deeds are more likely to be remembered if they are seen than if they are only heard. It is this sort of thinking that stimulated the

development of images such as the Man of Sorrows, or the mass of St Gregory, discussed in Chapter 2, which rely for their efficacy on the viewer's existing knowledge of the narrative context surrounding the image. While it is common to interpret Gregory the Great – and those who supported and developed his views – as having described images in general as the 'books of the illiterate', it is clear from Gregory's letter that for him the instructive function of religious pictures was particularly fulfilled by narrative images. A narrative image, or *storia* in Latin, was distinguished from a non-narrative image, such as an icon, which would be described as an *imago*. An *imago* might represent a holy person, such as Christ, or one of the saints (and was therefore much more problematic because it might be thought to encourage or allow idolatry, as we saw in the Introduction), whereas a *storia* represented an event, or a set of events. It is this latter category of image that, according to Gregory, could most usefully function as a substitute for the written narratives of the scriptures, for those who could not read. This section will focus on a few types of narrative imagery, in different media, from different regions and dates, concentrating upon their functions and upon the different relationships between image and text that can be discerned in these narrative images.

Christianity was, from the start, a religion of the book. The New Testament, originally written in Greek, and the Hebrew scriptures, or Old Testament, were translated into Latin at the beginning of the 5th century CE, by St Jerome, and became the authoritative text of Christianity. The combined text in Latin was known as the 'Vulgate', because Latin was the 'common' (*vulgatus*) language of medieval European scholars and churchmen. When Bible texts began to be illustrated this tended to be done only with its individual books, written and illustrated as separate entities. Among the earliest surviving Bible illustrations are those from the so-called Cotton Genesis in London (British Library, Cotton MS. Otho B. VI), dating from the late 5th century. This manuscript was damaged in a fire in 1731 but charred fragments remain of most of its original 330 or so miniatures, forming an extensive visual narrative illustrating the

Book of Genesis. From this period onwards individual books of the Bible were written and illustrated, for use in religious services, preaching, missionary activity, monastic observance and study and, later, for private reading and prayer. The most important types of illustrated books for religious practice in the earlier Middle Ages were books containing the four Gospels, the first four books of the New Testament, and Psalters, containing the 150 Psalms from the Old Testament. Fragments of an early illustrated Gospel book from Italy survive in Corpus Christi College, Cambridge (MS. 286), with small narrative scenes from the life, miracles, and Passion of Christ. The manuscript is known as 'The St Augustine Gospels', and is believed to have been among the books brought to England by St Augustine on his mission to convert the English in 597. Missionaries would have used illustrated narratives like this to explain the Gospel stories to those whom they wished to convert, many of whom would have been illiterate and so would have been unable to read the scriptures themselves. But narrative images were also, of course, used and enjoyed by those who were not necessarily using them as substitutes for written scripture, but in order to illuminate and illustrate scriptural texts that they may have known very well already. After the early use of illustrated Gospel books and Psalters by preachers and missionaries, other books of the Bible began to be produced in illustrated form, some for the monastic and ecclesiastical milieux, but some also for private individuals. One of the most popular of these was the Book of Revelation, or the Book of the Apocalypse. About 140 illustrated Apocalypse manuscripts survive from the era before printing, and they continued to be produced in number in printed form. The earliest illustrated Apocalypses date from the 9th and 10th centuries, coming mostly from Germany and Spain, and these were presumably designed for liturgical use or monastic study. There is also a very large group of illustrated Apocalypse manuscripts from England and France, produced between the mid-13th and the 16th centuries. Although this group too was probably created initially for clerical use, the Anglo-French Apocalypses increasingly came to be made for wealthy and aristocratic lay patrons, including royalty.

The textual narrative of the Apocalypse lends itself to visual illustration in a particularly appealing manner. The text is dramatic and prophetic, taking place outside the bounds of historical time, as a vision of the end of the world. It is also uniquely personal, as the narrative consists of the visions experienced by the writer, traditionally identified as the writer of the Fourth Gospel, John the Evangelist. Therefore the text encourages illustrations replete with emotion and human reaction. The earliest of the Anglo-French illustrated Apocalypse manuscripts, as independent texts isolated from the New Testament, probably appeared at some time in the 1240s. They quickly became popular, and there are some 76 Anglo-French examples from the 13th and 14th centuries surviving today. One of the earliest surviving of these illustrated Apocalypses is *The Morgan Apocalypse* (Fig. 17), with 83 delicately-tinted framed drawings arranged in two registers on each page. The extraordinarily enigmatic text of the Apocalypse invited commentary and interpretation, and offered an extremely diverse set of intellectual experiences for different users. The text and illustrations could have been understood as commentaries upon contemporary events, or as prophecies of calamity in the future, but always with the calm final message of the triumph of good over evil. Commentators encouraged the reader to see in St John's Book of Revelation a reflection of events in the New Testament surrounding Christ's birth, life, and Passion, as well as a prediction of things to come. Figures and events in the Apocalypse were identified with biblical figures, so that, for example, the Woman of the Apocalypse, whose child must be rescued from the dragon who was attempting to devour it, was identified with the Virgin Mary, and her child was identified with Christ. The dragon was identified with King Herod, who initiated the Massacre of the Innocents in an attempt to destroy the Christ-child.

It is clear that the beauty of these manuscripts must have appealed to their patrons, regardless of (or besides) their religious or prophetic content, and it has sometimes been suggested that, as well as powerful commentaries on salvation history, these

17. *The Woman of the Apocalypse* and *St Michael Killing the Dragon*, from *The Morgan Apocalypse*, New York, Pierpont Morgan Library, MS. M. 524, fo. 8ᵛ, c. 1255–60

manuscripts were also something of a medieval 'coffee-table book', providing an exciting tale to be read and enjoyed, sometimes equated with medieval romances. As well as this, however, Apocalypse manuscripts could certainly have been used as instruments of personal, spiritual, or devotional contemplation, and presumably this versatility partly fuelled their popularity. During the 15th century the illustrated Apocalypse was made available to a wider audience by the production of printed, block-book editions. Block-book printing is a transitional form of publication between manuscripts and printing with movable type, in which pictures and text were produced by impressions made by individual wooden blocks carved in relief. Sometimes only the pictures were produced this way, with the text being inscribed later in ink. Six different editions of block-book Apocalypses were produced between 1430 and 1470 (with many copies made from each different edition), and these were based on a manuscript model that seems to have descended from the Morgan Apocalypse, discussed above. Like the Morgan Apocalypse, pages were laid out with pictures in two registers, and with a minimal Latin text in captions and speech scrolls.

The mental habit of seeing the Apocalypse text as a prophecy of things to come, and relating it back to events in the New Testament, was part of a much larger medieval practice of typological thought. Typology is a method of interpreting certain persons and events in the Old Testament as foreshadowing the deeds of Christ in the New Testament. So, for example, Moses, the leader charged with delivering the Hebrews out of slavery in Egypt, and leading them into the Promised Land (Exodus 12: 37–14: 31), was seen as a foreshadowing of Christ, who delivered humankind into eternal salvation by his death on the cross. The Hebrews' journey out of Egypt was seen as a foreshadowing of Christ's own journey and return in the Flight into Egypt (Matthew 2: 13–23). The elements in these typological relationships are known as 'types' or 'archetypes' in the Old Testament, and 'antitypes' in the New Testament. Thus Moses is a

'type' of Christ. This system underlined the unity of the Old and New Testaments, with the New Testament being seen as a fulfilment of the Old. As we have seen, connections were routinely made in Apocalypse illustrations and commentaries between the events portrayed therein and events in the New Testament. But a much more formal and extensive series of typological relationships formed the centre of a group of texts that were extremely popular in the late Middle Ages and early modern period, known as *Biblia Pauperum*, literally 'Bibles of the Poor'. (This term was originally used when referring to biblical summaries produced for mendicant friars and clerics, for whom poverty was an important part of their religious lifestyle. Therefore the reference to 'the Poor' probably refers to the churchmen who would have used them in teaching and preaching, and does not indicate that the books themselves would have been produced, originally, for poor people or even for laypeople.)

The earliest copies of the *Biblia Pauperum* were 14th-century manuscripts, but with the advent of the printed block-book, the *Biblia Pauperum* became available to a much wider audience, and began to be owned not just by clerics and preachers, but by laypeople also. As with the block-book Apocalypses, the woodblocks used for the *Biblia Pauperum* images used manuscript cycles as their inspiration. The early examples of the block-book *Biblia Pauperum* contained, like their manuscript models, 34 pages of images. Later, expanded versions were produced, with 40 pages of images, and most of the surviving examples follow this format. One example of the 40-leaf *Biblia Pauperum* is now in the British Library. Each page carries one antitype, in the middle of the page, with panels at the sides depicting types from the Old Testament (occasionally the types are from the Gospels or the Book of Revelation). Above and below this central triptych are two pairs of relevant prophets or patriarchs, with their names in scrolls, and with extracts from the relevant prophetic texts, to elucidate the nature of the typological relationships being drawn.

The illustration of the Crucifixion in this British library book (Fig. 18) contains several elements with which we have already become familiar, including the slumped figure of Christ, with his head bowed to one side, and the swooning Virgin, supported here not by her female companions, but by St John the Evangelist. The Old Testament types are two episodes that were very well-known, traditional prefigurations of the Crucifixion, Abraham's Sacrifice of Isaac (Genesis 23: 7–18) on the left, and Moses and the Serpent of Brass (Numbers 21: 4–8) on the right. The inscription beneath the image of Abraham explains that 'The father sacrifices this boy who signifies Christ'. The parallel with Christ is obvious: God the Father sacrificed his son, as a result of his love for humanity. Abraham, as the text panel above the image explains, was prepared to sacrifice his son, as a result of his obedience to God, who put Abraham to the test. At the last moment, just as Abraham was about to kill his son, an angel appeared and stopped the sacrifice, offering a ram to be sacrificed instead. This moment of the narrative is clearly indicated in the image, with the angel grabbing Abraham's arm, in which is lifted the sword, and with the ram, the substitute sacrifice, in the foreground of the image. Isaac kneels quietly, with his back turned to his father, so that, despite the drama inherent in the message of the episode, the visual representation itself is rather still.

The episode of Moses and the Serpent, on the right, focuses more upon the salvation obtained as a result of Christ's death than upon a father's willingness to sacrifice his son. The inscription beneath the image of the serpent, raised up on a stake, declares that 'The hurt are healed when they look at the serpent'. As the text panel above the image explains, the Israelites, while in the Egyptian desert, had been plagued by serpents with a poisonous bite. Moses sought the advice of God, and was instructed to fashion a serpent out of brass, and raise it up on a stake. Anyone who had been bitten by a poisonous serpent looked at the brass serpent and lived (Numbers 21: 6–10). As the *Biblia Pauperum* text explains:

18. *The Crucifixion*, from the *Biblia Pauperum*, London, British Library, Blockbook C.9 d.2, *c.* 1470

> The serpent hung up and stared at by the people signifies Christ on
> the cross, whom every believing person who wishes to be rid of the
> serpent (that is, the devil) should gaze upon.

In the foreground two unfortunates are attacked by serpents.
Behind them Moses points at the brass serpent, guiding the rest of
the onlookers to gaze upon it.

The three images of Abraham and Isaac, the Crucifixion, and Moses
and the Serpent are arranged within the pseudo-architectural
framework so that there is a visual axis across the three that invites
the direct comparison of the boy Isaac, Christ, and the serpent.
Thus the artist has arranged the two Old Testament compositions
so that the direct types of Christ – Isaac and the serpent – are closest
to the inside edge of the picture plane in each case, as close to the
Crucified Christ as possible. This helps the viewer to make the
necessary connections, and the texts above and below each Old
Testament image explain the significance of the chosen types. Four
texts from the prophets Isaiah, Habakkuk, Job, and King David
further help to show that Christ's birth and death was foretold in
the Old Testament many times and in many ways. Finally, at the
bottom of the page, one phrase acts as an overall 'caption' to this
ensemble of text and image: 'The suffering of Christ snatches us
from the gloomy abyss'.

Having looked at two examples of narrative imagery in books,
probably to be used by one or two individual viewers at a time, let
us now turn to some larger scale images, in mural paintings, on
the walls of churches, designed to be viewed by whole
communities and congregations. The most common subjects for
narrative imagery in early Christian church decoration were those
from the first few books of the Old Testament – in particular, the
episodes from Genesis concerning the creation of the world, the
creation of Adam and Eve, their temptation and fall, and those
from Exodus concerning Moses and the Israelites. The great
basilicas of early Christian Rome depicted narrative imagery of

these subjects on their long nave walls, establishing systems for the use of such pictorial decoration that continued to be emulated in Christian churches throughout the Middle Ages and beyond. These churches arranged cycles of narrative imagery – either painted or in mosaic – that ran from the east end of the church to the west end. The best preserved of these early narrative decorations is in the church of Santa Maria Maggiore, where both walls carry 5th-century mosaics depicting scenes from the Old Testament, telling the story of the establishment of Israel through to the lives of the patriarchs. These are arranged with the earliest scenes on the left-hand wall, as a viewer looks at the altar, and the later ones on the right. The pictorial fields are roughly square in format, and each field is divided into two superimposed zones. Since each wall begins its narrative at the east end, at the apse, this has the effect that the right-hand wall is followed in the 'normal' left-to-right disposition of western writing, whereas the left-hand wall is read 'back-to-front', as it were, compared with textual narrative.

This arrangement, and this mode of 'reading' the narrative cycles, was further developed in the other main basilicas of Christian Rome, St Peter's, St Paul's, St John Lateran, and others. These churches were probably decorated by the 5th century, like Santa Maria Maggiore, but were refurbished and redecorated probably in the 8th and 9th centuries. The interior of St Peter's as we see it now is the product of the 16th-century rebuilding programme, under Bramante and Michelangelo, which completely replaced the medieval basilica. However, we do have indications of the original appearance of the medieval church (now normally known as Old St Peter's, to distinguish it from its Baroque successor), because of a series of drawings by Jacopo Grimaldi. These drawings, carried out during the first two decades of the 17th century, show cross-sections of the original interior, indicate the location of altars and monuments, and reproduce, as far as possible, the parts of the painted wall decorations that had survived up to the end of the 16th century. From Grimaldi's drawings we can tell that the upper

zone of the nave walls contained large figures of apostles, standing in pairs between the windows.

The cycles of narrative imagery began on the tier below, under the windows, on the right wall. The narrative probably began with the creation through to the life of Isaac, reading from left to right, from the apse to the entrance wall. The narrative then returned to the apse wall, where the viewer continued to follow the narrative by studying the next level of the wall, again from left to right, apse to entrance. This lower tier contained episodes from the stories of Joseph and Moses. On the opposite wall, the left as one looks to the altar, New Testament subjects were depicted, again beginning at the apse end, and moving towards the entrance wall, in two tiers, but this time, obviously, reading from right to left.

A Blessing at Bethany
B Doubting Thomas
C Harrowing of Hell
D Crucifixion
E Baptism

II. Layout of wall paintings at Old St Peter's

It is clear from Grimaldi's notes and descriptions of the church, and his drawings, that few of the cycle of 44 christological subjects remained to be recorded by the 17th century, but it seems that the cycle must have been an extensive collection of scenes from the life of Christ, running from his Infancy to the Passion, and on into his post-Resurrection apparitions and miracles. In the 17th century six scenes were still visible (Diagram II), including the Baptism of Christ, the Raising of Lazarus, the Harrowing of Hell, Doubting Thomas, and the Blessing at Bethany. The Blessing at Bethany scene is not mentioned in Grimaldi's description, but is visible in the drawing. Conversely, the Raising of Lazarus is mentioned in the notes, but is not visible in the drawing. One scene that is very clearly represented in Grimaldi's drawing is the Crucifixion, which occupies the space of four of the normal-sized scenes. This places a special emphasis on the event of Christ's sacrificial death, as the central and climactic event of Christian narrative. This particular emphasis on the Crucifixion became to a certain extent traditional, and was reproduced in other, later cycles of narrative imagery in Rome and Central Italy, including Sant'Angelo in Formis (11th century), St John Lateran in Rome (12th century), and the Collegiate Church at San Gimignano in Tuscany (mid-14th century). Another feature of the decoration of St Peter's that was widely copied in Italy was the typological disposition of Old and New Testament imagery on opposite walls of the nave. In fact, it has been suggested that no form of church decoration was more common in medieval Italy than the juxtaposition of Old and New Testament narrative cycles. Other early Christian basilicas in Rome were decorated to a similar pattern as that found at Old St Peter's. The church of San Paolo fuori le mura (St Paul-outside-the-walls) had a similar two-tiered scheme of narrative running from the apse to the entrance wall, on both sides of the nave. In this case, however, the Old Testament scenes were on the right wall, rather than on the left, and were paired with scenes from the life of St Paul on the left wall. (In fact, Old St Peter's probably originally had a cycle of St Peter on the right wall, until the 8th or 9th century, when the Peter cycle was replaced by the life of Christ, and the

Petrine cycle was recreated in the right transept.) The church of St John Lateran also seems to have used a typological scheme of paired Old and New Testament scenes. Although there is no direct evidence for the original decorations, because of the destruction wrought by an earthquake in the late 9th century, the 17th-century reconstruction by Francesco Borromini used the description made in 787 by Pope Hadrian I to create a set of strongly linked typological pairings. The system continued in Rome into the Renaissance period: the Sistine chapel, the papal chapel decorated between 1481 and 1483 under Pope Sixtus IV, also used typologically paired Old and New Testament cycles, from the life of Moses on the left wall, and the life of Christ on the right. The Sistine chapel wall frescoes have always been recognized as strongly inspired by the decorative scheme at Old St Peter's, and were almost certainly designed to make reference to the early era of the Christian church in Rome, as a statement about the continuity of the church.

In order to explore an example of how traditional typological juxtaposition and the opposition of different narrative cycles could be made to perform even more complicated devotional and interpretative functions, let us turn, for the remainder of this chapter, to the church of S. Francesco at Assisi. Here, the earliest painting on the nave walls recalls the old Roman typological schemes. In the upper parts of the nave bays, flanking the long two-light windows, are two tiers of painted scenes, carried out by various Roman painters, under the initial direction of Jacopo Torriti, probably beginning in the 1280s. As with Old St Peter's, this part of the decoration of S. Francesco in Assisi comprises scenes from the Old Testament on the right wall, placed opposite scenes from the New Testament on the left. The narrative of the Old Testament begins with the creation, at the apse end of the upper tier of the right wall, and goes through eight scenes, including the fall and the expulsion of Adam and Eve, and ending with the murder of Abel by Cain. The direction of the narrative then returns to the apse end, and drops down a tier, as it did at Old St Peter's, running through

eight more scenes, from the building of the ark, through episodes concerning Abraham and Isaac, Jacob and Esau, and Joseph and his brothers. The left wall comprises an Infancy cycle in the upper tier, running from the Annunciation to the Baptism of Christ, and a Ministry/Passion cycle in the lower tier, from the Feast at Cana and the Raising of Lazarus at the apse end to the Resurrection at the entrance end. As with St Peter's, the Old Testament scenes were read left to right, and the New Testament scenes right to left. The parallel of text and image in terms of left-to-right reading order was thus sacrificed in favour of achieving a parallel reading direction of the typologically paired schemes, from apse to entrance. This allowed the earlier parts of the narrative on each wall to be paired with the early parts of the narrative on the other wall, and so on. Unlike Old St Peter's, however, the scenes at S. Francesco are all roughly the same size, so the Crucifixion is not given more space.

The two tiers of biblical images follow more or less the narrative structure of the Bible text itself, and are concerned with the recording of events by the use of images that repeat visually the essential features of the relevant textual narratives. But below the Old and New Testament scenes is another register of imagery, recording the life of St Francis of Assisi, who is buried in this church. This Franciscan cycle was painted after the biblical scenes, perhaps in the 1290s, by a workshop that probably contained both Roman and Central Italian painters. Some people have even seen the hand of a young Giotto in this cycle, and others have seen Giotto as the controlling master of this project. For the purposes of this inquiry, however, the precise identity of the persons responsible for the cycle is not relevant. This cycle of the life of St Francis, unlike the Old and New Testament cycles, runs all the way around the interior of the church, in one direction, from left to right, from the apse end of the right wall, down to the entrance, across the interior of the entrance wall, and up the other nave wall, still reading from left to right, to the apse end of the left wall. In some respects this narrative cycle, too, is closely dependent upon the text on which it is based, the official Life of St Francis by Bonaventure, written in 1260. But there

are ways in which the visual narrative departs from the shape and structure of the textual narrative, in order to make theological and ideological points that are specifically dependent upon the visual connections between individual scenes in this cycle, and between scenes in this cycle and scenes in the biblical cycle above. For example, the ordering of some scenes in the visual narrative departs from the order in which they are presented in the textual Life of St Francis. However, this does not compromise a chronological 'reality', as established by Bonaventure, as it is clear from his Preface to his Life of Francis that chronological relationships took second place in this text to thematic ones. Bonaventure declares:

> To avoid confusion, I did not always weave the story together in chronological order. Rather, I strove to maintain a more thematic order, relating to the same theme events that happened at different times, and to different themes events that happened at the same time, as seemed appropriate.

In the cycle of visual narrative at Assisi, there is a notable departure from the order of events even as recorded by Bonaventure. In chapter 4 of Bonaventure's text, it is recorded that St Francis appeared miraculously to the Franciscan community at Arles, while St Anthony of Padua was preaching to the brothers in the chapterhouse, on the subject of the inscription on Christ's cross: 'Jesus of Nazareth, King of the Jews' (John 19: 19). Francis was seen in the doorway of the chapterhouse, 'lifted up in mid-air, his arms extended as though on a cross, and blessing the friars'. In the painted cycle at Assisi, this scene appears much later in the narrative than its placement in Bonaventure's text (Diagram III). Rather than appearing as the ninth scene, as it would if it appeared in the chronological order of the text, it appears as scene eighteen, and is consequently inserted between episodes that are recorded in chapters 12 and 13 of Bonaventure's text. On the whole, although the artists have had to select a finite number of scenes to illustrate from Bonaventure's long text (28 in all), the painted narrative does, for the most part, follow the order of the written text. So why is *The*

Apparition at Arles moved from where it would logically appear, if following the order of the text, somewhere around the third bay of the right wall, over to the entrance bay of the left wall? The answer lies in the opportunity to make a point about the closeness of Francis to Christ (Fig. 19).

Francis was known by his followers as an 'alter Christus', another Christ, and Bonaventure's Life takes every opportunity to emphasize the ways in which Francis's life, and personal qualities, were close to Christ. Throughout the text there are many references to Francis's devotion to, and constant meditation on, the Passion of Christ. In moving *The Apparition at Arles*, so that it occurs immediately next to *The Stigmatization*, the artist gains an opportunity further to emphasize the closeness of Francis to Christ. The artist places Francis centrally in the doorway of the Arles chapterhouse, with 'his arms extended as though on a cross', thus visually comparing Francis with the Crucified Christ. In the adjacent scene of *The Stigmatization* Francis's identity as 'alter Christus' was made visibly clear. The saint, having imitated Christ throughout his life, is rewarded with a direct physical manifestation of his closeness to Christ, and receives the actual marks of Christ's crucifixion, the wounds (*stigmata*) to his hands, feet, and side.

The particular disposition of scenes in the next bay of the church (Fig. 20) further emphasizes the representation of Francis's closeness to Christ. The scene depicting the death of Francis is placed directly beneath the death of Christ on the cross, in the New Testament cycle which, as we have already seen, was painted in the upper part of the left wall (Diagram III). The viewer, seeing these two scenes in close proximity, would have been further reminded of Francis's identity as an 'alter Christus', another Christ. In addition, the particular disposition of the Franciscan scenes in this bay, with *The Death of St Francis* on the left, and *Visions of the Death of St Francis* immediately adjacent, allows the artist to express visually an aspect of the narrative that Bonaventure found harder to convey. As Bonaventure's Life of Francis explains, at the time that Francis's soul

N E S W

New Testament Scenes

St Francis Series

14 15

St Francis Series

New Testament Scenes

13 12 11 10 9 8 7 6 5 4 3 2 1

16 17 18 19 20 21 22 23 24 25 26 27 28

Old Testament Scenes

St Francis Series

CROSSING

III. Layout of Assisi frescoes

19. The Master of the Legend of St Francis, *The Apparition at Arles* and *The Stigmatization of St Francis*, Assisi, S. Francesco, Upper Church, 1290s(?)

20. The Master of the Legend of St Francis, view of bay with *The Death of St Francis*, *Visions of the Death of St Francis* and *The Verification of the Stigmata*, Assisi, S. Francesco, Upper Church, 1290s (?)

'was freed from his body', one of his disciples saw the soul 'being carried aloft . . . on a direct path to heaven'. This we can see in *The Death of St Francis*: the friar kneeling behind Francis's head, to the left of the picture, looks upwards and points above to the image of Francis's soul being carried heavenwards by winged angels. At the same time, the text relates, Brother Augustine, the minister of the friars at another Franciscan community, distant from Assisi, was on his deathbed. Suddenly, he sat up, and cried out that he could see Francis on his way to heaven, and that he himself would soon follow. Whereupon Brother Augustine died, and, as Bonaventure puts it, his soul 'followed his most holy father'. This is represented in the next scene, the *Visions of the Death of St Francis*. The composition and arrangement of the two adjacent scenes allows the artist to depict Brother Augustine sitting up, and looking left and upwards, as though he sees into the scene on the left. In this way, Augustine does, indeed, appear to see the soul of Francis rising to heaven. This allows the miraculous simultaneity of the two events to be expressed very emphatically, and the significance of the event is more easily articulated in visual terms than in the original written text.

The general meaning of these two adjacent scenes – that at the death of Francis his soul was seen rising to heaven by two different followers, one physically present, and one physically distant – was probably more or less comprehensible without a very deep knowledge of the text upon which the images are based. But an understanding of the direct significance of the placement of *The Apparition at Arles*, and of the juxtaposition of the death of St Francis with the death of Christ, would probably have required a little more textual knowledge.

We may now return to the idea of pictures such as these as 'books for the illiterate'. Could the 'illiterati' have learnt from these images that which they could not read in texts? It would seem that those who devised the programme at Assisi did not think that the intended message carried by the images was obvious enough in itself, as inscriptions were included beneath each scene. But these

inscriptions are in Latin, and so would not have been of much benefit to the 'illiterati'. Even those people who could understand vernacular Italian might have struggled to read the Latin extracts from Bonaventure's text beneath these images. As suggested earlier, the *combination* of texts and images might have helped those whose level of literacy in written Latin was not particularly high to piece together what was going on in any of these images. But the fullest impact of the rearranged placement of *The Apparition at Arles*, and the symbolic value of its placement near *The Stigmatization of St Francis*, would have required the viewer to know the narrative structure of Bonaventure's text well enough to note that the episode was out of place here.

The relationships between text and image, and between different images, in the St Francis cycle are rich ones, especially when the relationships are allowed to extend, typologically, to the connections between the Francis cycle in the lower register and the New Testament cycle above. This complexity suggests that, in this instance at least, images were not simply acting as 'books for the illiterate' and that the visual narrative of the St Francis cycle might have been of relatively limited use for 'instruction of the ignorant'. The images might, with some direction, have been used to teach people the story of St Francis's life, but they are clearly designed with a much more complex learned audience in mind, not least the Franciscan friars themselves, some of whom would have known the Latin of Bonaventure's Life of Francis very well indeed, and would have been able to use the images, and the inscriptions, together with the written text, as highly developed meditative aids. These images were a sophisticated development upon the early Christian narrative images designed to illustrate and accompany a text. Therefore, these texts and images, together, offer a range of reading experiences for a range of viewers, and can be regarded as 'books for the illiterate' only in a very limited sense: these and other similar sets of narrative imagery have in fact been recognised by Hans Belting as 'learned statements in visual form', perhaps originally apprehended fully only by those with education and experience.

Chapter 5
Christian art transformed: The Reformation

Besides general changes and developments in artistic and architectural style, there have been several periods and processes of conscious reform in Christianity that have resulted in greater or lesser changes to art and its place in Christian worship and observance, and to the appearance of Christian art and architecture. These include the various periods of iconoclasm in the early church, and the 12th-century reform movement within western monasticism that resulted in the formation of the Cistercian Order. But perhaps the most widespread and far-reaching changes to the appearance of Christian art and architecture, and the greatest reconsideration of the place of art and images within Christian observance, occurred as a result of religious reforms in 16th-century Europe. Although this period, with its religious changes, is normally described as 'The Reformation', this expression is really a shorthand for a number of reforms and movements, both religious and political in nature, that took place in different ways in different areas. Historians often divide the changes into two main strands, 'The Reformation' or 'The Protestant Reformation', and 'The Counter-Reformation' or 'The Catholic Reformation'. The first of these strands is that movement or collection of movements that gathered enough momentum during the early 16th century to result in a Protestant break with Rome and the continued development of distinct Protestant communions and communities within the wider

Christian church. The second describes the process by which the Catholic church was reorganized and reformed in the 16th century and after. (The term 'Counter-Reformation' suggests, to some commentators, that the reform and renewal of the Catholic church was mainly or only a reactive process, forced on it by the Protestant Reformation. For this reason, the term 'Catholic Reformation' is often preferred in modern scholarship.)

For the most part the Protestant Reformation affected the production of Christian art in two ways: first, in some branches of Protestantism, the very existence and function of religious art was called into question, and traditional religious art was removed from some Protestant churches, either in violent outbreaks of iconoclasm, or by more measured, official processes of image-removal; secondly, where Christian art continued to be produced, for the Catholic church, and for some less radical Protestant reformers, such as the Lutherans, it now became available as a polemical weapon in promoting the different theological positions by which the various denominations defined themselves. There is not space here to consider in detail the theology of the different Protestant reformers, and the different forms in which Protestant observance developed after the early 16th century, except in so far as reformist views had an impact upon attitudes towards, and production of, Christian art.

At first, theologians and reformers in the early 16th century made few explicit statements concerning art per se. Martin Luther (1483–1546), the Augustinian canon and lecturer at the University of Wittenberg, is often identified as the 'founder' of Protestantism, and the leader of the German Reformation, even though he himself made no claims to spiritual leadership. Luther initially spoke out against images only in terms of the money that it cost to produce them, and which he believed could be better spent in other ways. Then, as he further developed his doctrine of 'justification by faith', he came to a more particular position on images. This doctrine held that believers were saved by faith in Christ and by the gift, freely

given, of grace from God. In developing this doctrine, Luther sought to correct the prevalent Catholic belief in the saving power of 'good works', whereby salvation was seen in some sense as the product of a 'bargain' or 'transaction' between human beings and God. The doctrine of 'good works' was manifested in several ways in the late medieval church. First, and most objectionable to Luther, was the trade in 'indulgences', by which the church would grant remission of the penalties of sin, initially for the performance of some worthy deed, such as a pilgrimage, but later on for a more simple payment of a monetary fee. But beyond this particular practice, there was a widespread belief that the performance of 'good works' would obtain merit, or favour, with God. It was in this connection that Luther saw a danger in religious art: he became opposed to the endowment of artworks with the intention of earning merit with God, although he maintained the position that images, in themselves, were neutral, neither good nor bad. Lutheran reformers, and the communities that followed Luther's attitude to images, did not seek to rid churches of art entirely. In fact, Luther continued to praise the educational merits of religious art, and to value its benefits for 'children and simple folk', echoing Gregory the Great (see Chapter 4). He categorically opposed the instances of iconoclasm that had been occurring in Wittenberg in the early 1520s, and adopted a moderate stance towards images, even as he promoted a word-based faith.

Other Protestant reformers were more hostile to images and artworks, however. In Zurich, where Ulrich Zwingli (1484–1531) gave expression to the Reformation in Switzerland, art was banned from churches in 1524, and all images were removed (although without any actual destruction or iconoclasm). Geneva followed suit in 1535, where Jean Calvin (1509–64) had pronounced on the making of images as a misunderstanding of the nature of God, and upon attempts to depict God as an affront to his divine majesty. These image-removals resulted in the 'beautifully white' church interiors (in the words of Zwingli), such as those later immortalized

in the paintings of church interiors by the 17th-century Dutch artists Pieter Saenredam and Emanuel de Witte. Calvin, unlike Luther, did not accept the utility of images for 'children and simple folk', and affirmed instead the role of the word of scripture, with a direct opposition of word and image. In Calvin's opinion, churches should contain no images or crucifixes at all, and should be adorned only with inscriptions from the Bible. Thus in some strict Calvinist communities, Christian art disappeared almost entirely from the public, ecclesiastical sphere, and many Calvinist churches removed traditional altarpieces and images of saints and replaced them with textual tablets with biblical texts, the Ten Commandments, or the Lord's Prayer. Therefore, in such communities, the development of reformist ideas changed the market for, and production of, Christian art significantly. Large ecclesiastical commissions for altarpieces all but disappeared in many areas, and in others there was a distinct reduction in the demand for many traditional types of religious painting, including pictures of the saints, and of the Virgin Mary.

New altarpieces continued to be commissioned for Lutheran churches, although they differed somewhat from their Catholic predecessors in the images used. There was a growing focus upon images based upon scriptural sources, particularly those concerned with the life of Christ, his Passion, and Resurrection. The City Church at Wittenberg, whose altar had been stripped by the iconoclasts in 1522, received a new altarpiece in 1547, from the workshop of Lucas Cranach the Elder (Fig. 21).

Cranach was court artist at Wittenberg to Duke Frederick the Wise, Elector of Saxony, and thus found himself at the centre of the Protestant Reformation in Germany. His altarpiece for the City Church, in common with many Lutheran altarpieces, depicted the Last Supper in the central panel, with the Crucifixion below, making clear the connection between Christ's sacrificed body and the eucharist. (Lutherans, unlike those who allied themselves with the more extreme Protestant reformers, upheld the belief that the

21. Lucas Cranach the Elder, *Last Supper Altarpiece*, Church of
St Marien, Wittenberg, 1547

bread and wine of communion did not just represent or signify Christ, but were, truly, his flesh and blood, coexisting with the physical elements of bread and wine. Luther's principle objection to the contemporary Catholic doctrine of the eucharist had been to its scholastic philosophical explanation of the phenomenon of transubstantiation.) In the wings of the altarpiece were placed images of baptism and confession, the other two of the seven traditional Catholic sacraments that Luther affirmed (later Luther recognized only two, baptism and eucharist). The Crucified Christ appears in the centre of the predella panel, which also shows Luther preaching to his Wittenberg congregation, thus affirming the importance of the Word. This painting, then, celebrates Luther, and the central tenets of his version of Christianity, right in the geographical centre of his own ministry.

Outside the ecclesiastical sphere, religious images were seen as having an important role to play in the propaganda campaign waged by Lutheran Reformers against the Catholic church and its contemporary abuses. Most important were the printed pamphlets and broadsheets, containing woodcut illustrations, which criticized practices such as the sale of indulgences, promoted Lutheran theology and doctrines, and which became an essential component of Protestant rhetoric from the early years of the European Reformation. Cranach in Wittenberg and Holbein in Basle are probably two of the best-known exponents of Protestant polemic in woodcuts. Cranach had been producing religious woodcuts from the first decade of the 16th century. As Luther's ideas developed and spread, Cranach worked closely with him, producing woodcut illustrations for Luther's translation of the Bible into German (1522) and the later anti-papal tract *Portraits of the Papacy* (1545). Cranach also worked with Philip Melanchthon (a student and friend of Luther), producing a series of paired woodcuts to accompany a text by Melanchthon (*Passional Christi und Antichristi*, 1521) that contrasted the evils of the contemporary papacy with the goodness of Christ in the Gospels. This developed the traditional practice of typological

22. Hans Holbein the Younger, *The Selling of Indulgences*,
Basle, Öffentliche Kunstsammlung, *c.* 1522–3

juxtaposition that we saw in the block-books and wall-paintings of
Chapter 4. Holbein, too, created woodcuts translating Protestant
polemics into images. His woodcut of the *Selling of Indulgences*
(Fig. 22) compares within one image the papacy and the
contemporary clergy with Kings Manasseh and David, two
notorious sinners of the Old Testament, thereby commenting upon
the corruption of the modern church.

Many of these woodcuts thus turned old images to new ends, or
used old methods of juxtaposition and comparison of images in
order to create new messages. But as some old images were
turned to new, polemical purposes, other, completely new types of
images began to emerge which specifically represented some of
the new reformist doctrines that were being developed and
disseminated.

One particularly characteristic example of this phenomenon is
offered by the representation of the core Lutheran doctrine of
justification by faith. New allegorical representations developed to

illustrate this, focusing around the juxtaposition of the Law and the Gospel. These contrasted the era of the Old Law, before Christ, with the era of the New Law or the era of Grace, under Christ, where God's merciful gift of grace devolves upon the faithful, irrespective of individual believers' good works or attempts to gain merit. Artists developed this scheme in several ways, in drawings, paintings, and woodcuts, and it became a stalwart of Protestant iconography for the Lutheran reformist tendency. Hans Holbein the Younger produced a particularly successful version of this Law and Gospel theme, in a painting now in the National Gallery of Scotland in Edinburgh (Fig. 23). The general composition of this painting owes much to Cranach, in particular to a painting now in the National Gallery in Prague. Several versions of this theme are known from Cranach's workshop, all of which utilize an antithesis between the left side of the picture, containing scenes from the Old Testament, and the right side, with scenes from the new Testament, divided by a tree in the centre. In producing this composition, and its variant versions, it has been assumed that Cranach was advised by a reformist theologian, most likely Melanchthon, who mentioned in a letter his custom of providing Cranach with advice on the content of his religious paintings.

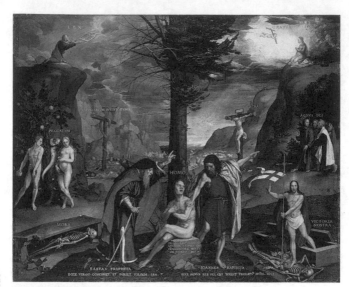

23. Hans Holbein the Younger, *The Old Law and the New Law*, Edinburgh, National Gallery of Scotland, 1530s

It is most likely that Holbein's painting dates from the 1530s, painted after he had left Basle for England, and produced for an English patron of reformist sensibilities. Holbein places a man in the centre of the composition. The left side of the picture field is divided from the right by a tree that occupies the full height of the picture. The tree is lifeless on the left, where the sky is dark, and green and leafy on the right, against a brighter, blue sky. This contrast indicates quite clearly that the right is the preferred side. A figure stands to each side of Man ('HOMO'), very pointedly gesturing and drawing his attention to the right side of the picture. One is the Prophet Isaiah, who points to the top right of the composition, where a figure of the Christ-child, bearing the cross of his future Crucifixion, comes down out of the clouds towards the Virgin Mary, who kneels as she does in some versions of the Annunciation. The cross-bearing Christ-child is also an element familiar from 15th-century northern European Annunciations, and

so it is obvious here that the vignette illustrates the moment of the Annunciation, precisely fulfilling Isaiah's prophecy, 'Behold a virgin shall conceive and bear a son' (Isaiah 7: 14), which is inscribed in Latin beneath him. In the background, behind the tree, an angelic figure swoops down from the bright clearing in the clouds where the Christ-child is seen, towards two shepherds guarding their sheep. This evokes the Annunciation to the Shepherds, in which angels made the shepherds aware of the Nativity of Christ. This element therefore further drives home the point that what we see in the top right-hand corner is the beginning of the earthly life of Christ, and thus the inauguration of Man's salvation. The figure of the Christ-child is accompanied by an inscription 'GRATIA' ('Grace'), which indicates that the incarnation of Christ initiated the new era of grace. This is contrasted with the old era of law, represented in the equivalent position on the left-hand side of the picture, where Moses receives the Ten Commandments, the Tablets of the Law, accompanied by the inscription 'LEX' ('Law'). Beneath the figure of Moses, in the background, the Israelites who had been bitten by fiery serpents (Numbers 21: 6–9) are shown gazing upon the serpent of brass, in the hope of being healed. They are accompanied by the inscription 'MYSTERIUM JUSTIFICATIONIS' ('Mystery of Justification').

In the middle ground, below the figure of Moses, the Fall of Man is represented by the Temptation of Adam and Eve, with the inscription 'PECCATUM' ('Sin'), and in the foreground is Death ('MORS'), represented by a skeleton in a tomb. The figure of Man in the centre has his attention drawn away from this side, and towards the right side of the picture, not only by Isaiah, but also by the figure of John the Baptist, who points to the figure of Christ with his Apostles. Christ is identified by his halo, and also by the inscription 'AGNUS DEI' ('Lamb of God'), which makes use of the old and instantly recognisable theme (that we have seen before) of John the Baptist's identity as the one who heralds Christ's coming, and John's description (John 1: 29) of Christ as 'the Lamb of God who takes away the sin of the world', which is itself inscribed beneath the figure of John. In the right background, directly paralleling the brass

serpent raised up in the desert, is the figure of Christ crucified, the real source of Man's justification or salvation, labelled as 'JUSTIFICATIO NOSTRA' ('Our Justification'). This typological juxtaposition of the Crucified Christ with the serpent of brass makes use of another well-used and recognizable theme, as we saw in Chapter 4. Finally, in the right foreground, the Resurrected Christ, with his red and white banner of victory, steps from the tomb, and tramples death and the devil. He is labelled 'VICTORIA NOSTRA' ('Our Victory') and indicates that Man gains his victory over death, eternal life, by his faith in the gift of Christ's death and resurrection, not by any good works performed by Man himself.

This composition illustrates perfectly the doctrine of salvation through faith and grace, and is therefore very much a product of the Protestant Reformation. Whether or not it perfectly reflects Holbein's personal religious sensibilities, on the other hand, is a question that continues to frustrate a simple answer. Holbein has often been described as the supreme representative of German Reformation art, and that judgement may be justified (although Cranach surely lays some claim to that title also). But where, precisely, Holbein stood on the religious questions of the day is much harder to ascertain. It is known that Holbein made an equivocal reply to the inquiry of 1530 into citizens' religious beliefs, set up in Basle by the reformist party. We learn from the 'Registers of the Christian Recruitment' that 'Hans Holbein the painter says that he needs a better explanation of Holy Communion before he will go'. Later his name is included among those who 'conform' so it is presumed that on that issue, at least, Holbein fell into line with the Basle reformers' view of orthodoxy. Much has been made of the apparent contradiction between this equivocation and the strongly Lutheran character of the woodcuts mentioned above, carried out in the first half of the 1520s. But it must be remembered that the Reformation was not a clearly unified and homogeneous movement, and that 'Protestantism' – and its Lutheran, Calvinist and other branches – was not yet clearly defined and agreed by all parties involved. In the 1520s and 1530s many

conflicting beliefs and interests coexisted in the areas where reformist views generally held sway, just as conflicting beliefs and interests had always been a part of the so-called universal Catholic church of the Middle Ages. It may be, as several scholars have argued, that Holbein had a general sympathy towards reform. Nevertheless, the existence of Lutheran broadsheets by Holbein on the subject of indulgences and the importance of a Christ-centred faith, and his production of an example of this law and grace theme, does not necessarily define clearly his own faith. Holbein might well have been opposed to the traffic in indulgences, and sympathetic towards the doctrine of 'justification by faith alone' throughout the 1520s and 1530s. But neither of these sympathies would necessarily preclude his having doubts about the reformist theology of the eucharist, which is all that the Basle 'Registers of Christian Recruitment' tell us. In fact, the Lutheran position on the eucharist was only codified at the Diet of Augsburg in 1530, and belief in 'justification by faith alone' was not necessarily a defining sign of Protestant allegiance until defined as such by the Catholics at the Council of Trent (1545–63). Therefore, none of what we see in Holbein's art at this time definitively identifies his own religious sensibilities. And the much more important point here is to recognize that Holbein's religious artworks are probably not self-generated statements of his own religious position. Whatever Holbein's personal sensibilities, he had to work, and had to attract commissions. Artists in this fast-changing and ill-defined political and religious climate adapted quickly to shifting conditions if they wanted to maintain their business. In the uncertain conditions of the early years of what we now call the Reformation, it does not follow from Holbein's acceptance of commissions for patrons of reformist sensibilities that through these commissions he sought to express a definitive version of his own spirituality.

After the Council of Trent, with the strengthening of the process of Catholic Reform and Counter-Reformation, and the continued codifying and increasing definition of religious positions – Catholic,

Lutheran, Calvinist – the character of Catholic and Protestant art, correspondingly, became increasingly defined. By the 17th century, in areas that had remained loyal to – or returned to – the old faith, Christian art continued to be commissioned as a powerful polemical weapon, promoting the Catholic view of Christianity. This was characterized by a continued and strengthened adherence to the Virgin Mary, and to Marian doctrines and representations that had been attacked by Protestants, such as the Virgin's Assumption and her Immaculate Conception (see Chapter 1), to the saints (see Chapter 3), and to the seven sacraments, with a particular emphasis on the eucharist, in the particular doctrinal form as defined by the Catholic church. Just as certain areas of Europe, such as Germany, Switzerland, and the Netherlands, had fostered and encouraged Protestant reform in the 16th century, so other areas became particular bastions of Catholic reform and Counter-Reformation in the 17th century. In the Southern Netherlands, now Belgium, political radicalism and resistance to the Spanish Habsburg monarchy in the 1570s under the auspices of Calvinist reform had produced a conservative reaction in favour of the monarchy and Catholicism. The Southern provinces were retrieved for Spain, and by the end of the 16th century Spanish-backed Catholic archdukes, ruling from Brussels, oversaw the recovery of the area for Catholicism. Meanwhile the Northern provinces remained independent and Protestant. Just as with the Protestant Reformation in the 16th century, so Catholic reform and the Counter-Reformation proceeded differently in different areas, and produced different types and styles of art (and architecture) as it developed.

In general, Catholic, Counter-Reformation art, emanating originally from Rome, adopted the energetic style of the Italian Baroque. Catholic churches were designed and refurbished in accordance with a general attempt to present the religious experience as an assault on one's physical senses, such that one's bodily attention would be captured, and then the mind's attention caught also. Elaborate and highly decorated interiors, sculpted,

painted, and gilded, filled with candles, addressed themselves to the sense of sight, while new, polyphonic music for the liturgy, and the use of incense, appealed to the senses of sound and smell. But while it is possible, in some senses, to identify a very general style of Counter-Reformation art, Italian, Spanish, and Flemish (Southern Netherlandish) Counter-Reformation art each has its own character and style, as did the pre-Reformation art of those areas. Having seen at least one example of Spanish Counter-Reformation art (Velázquez's *Immaculate Conception*, Fig. 7) and Italian Counter-Reformation art (Caravaggio's *Martyrdom of St Matthew*, Fig. 16) in earlier chapters, let us here briefly consider one image by Peter Paul Rubens, the most forceful proponent of Counter-Reformation art in the Southern Netherlands.

Rubens was born in Siegen, in Westphalia, in 1577. In 1598 he became a master painter in the Antwerp painters' Guild of St Luke, and soon after that, in 1600, went on an extended trip to Italy and Spain, where he was exposed to the work of Renaissance artists such as Raphael and Michelangelo in Rome, and experienced the growing religious and cultural effects of the Counter-Reformation in Southern Europe. When he returned to Antwerp in 1608 Rubens found himself in a city that was being renewed under the Catholic regime of the Archduke Albert and Isabella, where many churches that had been damaged during the instability of the second half of the 16th century were being redecorated, and new works of art of a distinctively reformed Catholic sensibility were being commissioned.

An excellent example of this sort of work is Rubens's *Real Presence of the Eucharist* (Fig. 24), in Antwerp's church of St Paul. The Catholic church was seeking to restore faith in the sacraments, and particularly in the real presence of Christ in the eucharist. The majority of Protestant reformers had come to see the Communion as simply a commemoration of the Last Supper, and did not accept the Catholic view that Christ's body and blood became really and fully present during the mass, as a result of the

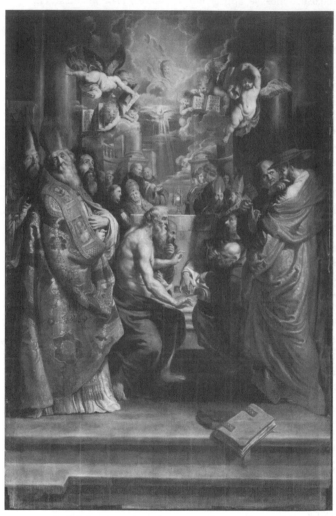

24. Peter Paul Rubens, *The Real Presence of the Eucharist*, Antwerp, Church of St Paul, 1609–10

process of transubstantiation, effected by the priest's consecration, or blessing of the bread. Therefore one of the crucial tasks that reformed Catholicism set itself was to restore and strengthen faith in, and devotion to, the eucharist as the actual manifestation of Christ's body on earth. The veneration and adoration of the eucharist was encouraged. New congregational devotions were developed, such as benediction, where the congregation were blessed with the host – the consecrated eucharistic bread – and the host was exposed to view in elaborate and precious monstrances designed for its display. In addition, images were commissioned that were designed to encourage the proper attitude towards the eucharist, and to demonstrate the ways in which the faithful should behave and think in its presence. Rubens's painting is one of those. It was carried out in 1609–10, to stand on the altar of the chapel of the Holy Sacrament in St Paul's church, where it still remains. In the centre of the panel, a monstrance containing the host is displayed on an altar, surrounded by saints, monks, and other churchmen. In the foreground theologians and philosophers consult and discuss a text which, it may be presumed, expounds the eucharistic doctrine. Above, cherubs display supporting texts, and surround a heavenly burst of light and cloud that reveals God above, and the dove of the Holy Spirit below him, with rays of light falling on the monstrance below. In this image we are invited to recognize this triad as the three persons of the Trinity: God the Father (the first), the Holy Spirit (the third), and the host in the monstrance, which is, according to the doctrine of the real presence, Christ, the second person of the Trinity. By the use of this well-known – and undisputed – concept of the Trinity, this painting succeeds in producing a literal and forceful representation of the Counter-Reformation concern with the real presence of Christ in the eucharist.

Elsewhere in the Netherlands, in the independent Dutch territories of the North, where Jean Calvin's vision of Protestant reform remained dominant, the market for altarpieces and official

ecclesiastical art was now non-existent. The private art market became dominated by landscapes, portraiture, and scenes of everyday life. Nevertheless, religious art continued to be produced, even in the Protestant Dutch Republic, and Rembrandt van Rijn was a particularly important exponent of this. Rembrandt was born in Leiden in 1606, attended Leiden University, and after some time he moved to Amsterdam, where he was apprenticed to Pieter Lastman, one of the foremost painters of his generation, a Catholic who had worked in Italy. In Amsterdam Rembrandt produced some large-scale, dramatic paintings, such as the five scenes of Christ's Passion, from the Raising of the Cross to Christ's Ascension into Heaven, which he produced for Frederick Henry of Nassau, Prince of Orange, in the 1630s. However, the market for commissions of this sort was relatively restricted in Protestant Amsterdam, and much of Rembrandt's religious work is represented by smaller scale paintings and drawings, many produced not in response to direct commission, but as a result of the painter's own choice.

Rembrandt has sometimes been characterized as a painter unique in giving artistic expression to Protestant sensibilities. This is clearly an exaggeration, as our consideration of Cranach's and Holbein's work in 16th-century Germany, Switzerland, and England makes clear. But much of Rembrandt's work is often seen as exhibiting a general affinity with Protestant sensibilities. Many of Rembrandt's religious artworks focus on biblical narratives. This contrasts with the renewed concentration on the saints, the Virgin Mary, the sacraments, and the authority and hierarchy of the earthly church, which one finds in Catholic painting of the time. In addition, the pared-down, rather minimal style of some of Rembrandt's work is in contrast to the dramatic, emotional assault on the senses with which Counter-Reformation art expressed the world-view of the Catholic church. As Mariet Westermann has suggested, 'intimate renderings of biblical stories' were Rembrandt's 'distinctive contribution to religious painting'. However, it is difficult to be certain about Rembrandt's personal

religious outlook. His parents were married in a Calvinist church, but may not necessarily have been particularly committed to Calvinism. Rembrandt himself seems not to have been an official member of the Calvinist church, for when his mistress Hendrickje Stoffels was summoned and censured by the Calvinist church council on account of their sexual relationship Rembrandt himself received no such attention. This was probably because church discipline extended only to Calvinist members, and Rembrandt was not a church member. Attempts have been made to connect him with the Mennonites, a reformed sect who based their observance on the literal content of the Bible, and upon nothing subsequently introduced into Christian observance. This cannot be certain, and it does not much matter whether Rembrandt would have identified himself officially as a Calvinist or a Mennonite, or as a member of no particular sect: his work, or much of it, certainly seems to be informed by a different spirit from that of the Catholic art of the period. It is possible to find in Rembrandt's painting, mostly in the early part of his career, definite similarities with Rubens and with the Italian Baroque in its dramatic aspect, reliant on strong displays of human emotion, gesture, and facial expression (see, for example, *The Sacrifice of Isaac*, St Petersburg, Hermitage, 1635). On the other hand, there is a strong thread, from early in Rembrandt's career, of a different type of conception, where strong movement, ostentatious gesture, and theatrical drama are left aside in favour of quieter, stiller scenes, with an emphasis on the state of mind of human beings, and on the individual's interaction with the divine. A fine example of this is Rembrandt's late painting of the *Return of the Prodigal Son* (Fig. 25).

In most representations of this parable, much narrative detail is present, with literal renderings of the biblical description (Luke 15: 11–32) of the activities of family members and servants, preparations for the feast, and the bringing of new clothes for the returned son. Other representations focus upon the son's dramatic repentance and remorse, with extravagant gesture or contorted facial expression. Here, in contrast, the son is quiet, and buries his

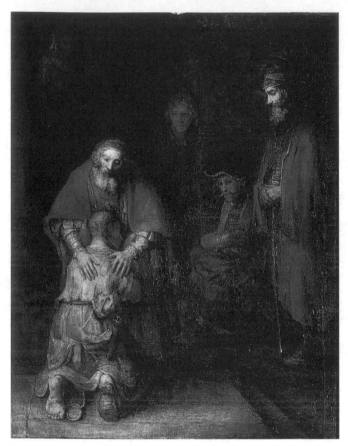

25. Rembrandt van Rijn, *The Return of the Prodigal Son,* St Petersburg, Hermitage, *c.* 1666–8

head in his father's chest. The firm and comforting embrace of the father, and the absence of spoken interaction between the two, indicates silent forgiveness and concentrates on the enduring and loving relationship of a father for his son. Rembrandt's treatment of this biblical subject invites quiet contemplation, rather than stirring up violent emotion, as an equivalent Counter-Reformation

treatment of the subject might seek to do. It suggests a more Protestant conception of the notion of human salvation and reconciliation with God, which, as the Protestant reformers taught, and art of a Protestant sensibility sought to show, was derived from the unearned, but freely given grace of God, not as a result of any actions of human beings.

Chapter 6

Christian art around the turn of the second millennium

Throughout the 20th century and into the 21st, Christian art has continued to be produced for Christian communities and individuals. New Christian cathedrals, churches, and chapels of all denominations continue to be built, rebuilt, and refurbished, with the consequent requirement for new Christian art and Christian church furnishings. Much could be written about recent and contemporary Christian art in these settings, and many major artists of the 20th century have produced well-known works of art for Christian churches in Britain, Europe, North America, and beyond, including Eric Gill, Marc Chagall, Henri Matisse, Jacob Epstein, Elisabeth Frink, and Graham Sutherland. In producing works for the interiors of Christian churches, to be used as part of Christian worship, or to enhance the experience of Christian worship, these and other artists are continuing in the traditions I have examined throughout this book. In the modern era, however, artists have also produced what might still be termed Christian art, dealing with many of the same themes and concepts that we have already seen, but which was never designed to function as part of an environment of Christian worship. This art has other points to make about the relevance or otherwise of the still-enduring Christian message or of familiar Christian imagery. In this connection, we might think of the British painter Stanley Spencer

(1891–1959), who painted a series of pictures locating biblical events such as the Nativity, Christ Carrying the Cross, and the Resurrection, in his home village of Cookham. The British Pop Artist Peter Blake, in his *Venice Beach Madonna* (1996), mixes an image of the Virgin Mary, based upon a medieval prototype, with the modernity of Venice Beach in California.

There is, therefore, both continuity and development in the production of Christian art, in its widest sense, in the modern era. But the biggest difference between the art of the 20th and 21st centuries and that which went before is that in the modern period Christian imagery has, as I hinted at the outset of this book, become part of the general vocabulary of contemporary visual culture, and thus it can now be used and understood in contexts totally outside Christian worship or devotion. Despite this, works of art using Christian themes are obviously still dependent on the weight of Christian tradition and Christian art for their meaning, and as such can still stir up strong and sincerely felt reactions, both positive and negative.

I want to finish with two images – a painting and a photograph – that, in basic terms, deal with themes and subjects that I have already examined: one is an image of the Virgin Mary, the other an image of the Crucified Christ. However, these two images differ from those we have already examined. They were not created to fulfil a Christian function: they were designed as independent artworks, to be displayed in the modern setting of the art gallery and museum, rather than in a church. Nevertheless, these works gain their power by making reference to well-known Christian images and concepts with which European and American culture is so strongly imbued, and both were created by artists brought up within the Christian tradition. Both works have created enormous controversy, caused huge offence to other Christians, and been the subject of much media attention, because of their introduction of non-traditional elements to deeply traditional images.

The Holy Virgin Mary (London, The Saatchi Collection, 1996), by the contemporary British artist Chris Ofili (b. 1968), was a controversial element of the 'Sensation' exhibition at London's Royal Academy in 1997. It became the centre of even greater controversy when the Mayor of New York City, Rudolph Giuliani, threatened to withhold city funding from the Brooklyn Museum of Art, and threatened the museum with eviction from its city-owned building, when the museum exhibited this painting in the autumn of 1999. Giuliani condemned the exhibition, and singled out Ofili's painting as particularly offensive, deeming it 'inappropriate' that public funds should be used to exhibit such a work. (A Federal judge eventually ruled in favour of the museum, and ordered the city to restore its funding.)

The style and composition of the woman's face and body depart from the traditional images examined so far, but it was not the form of the image of the Virgin itself that put this painting at the centre of controversy. The problem with the work, for most people, and the aspect that received most attention, was the fact that the painting has lumps of elephant dung stuck onto the painted surface. Some felt that it was simply unacceptable for this substance to be appended to an image of the person whom Christians believe to have been the Mother of God. They felt that Ofili had set out to be deliberately offensive by this juxtaposition. But elephant dung has formed part of many of Ofili's works before this one, and is in large part, according to the artist himself, and other commentators upon his work, a cultural reference to the artist's own African heritage. Ofili, a black Briton of Nigerian descent, visited Africa for the first time in 1992, a visit that apparently had a great effect upon him. After this visit he started using elephant dung in his paintings, as a reaction to what he had seen and felt in Africa, as a way of linking his work with the very fabric of the African earth and landscape. In this context, once one is aware that the use of elephant dung in Ofili's work is not unique to *The Holy Virgin Mary*, it is possible to interpret the use of elephant dung here as extending a long-running idea in Ofili's work, linking the Christian

message, an important part of the artist's upbringing, with his cultural and ethnic roots in Africa.

This raises the important question whether, in works of this nature, the artist's intentions determine the 'correct' interpretation of the work. Would it – or should it – necessarily make any difference, to a viewer who was offended by the use of elephant dung in an image of the Virgin Mary, to know what the elephant dung signifies for the artist, and why, in the artist's view, the juxtaposition is appropriate? In some cases, even armed with this additional information about the artist's intentions, a viewer may, nevertheless, still feel that this work is offensive to him or her. An interesting aspect of this work and its reception, therefore, is that meaning is shown to be in the eye of the beholder, at least to a certain extent. One's reaction to the work as a whole is necessarily subjective, and depends upon one's own interpretation of the individual aspects of the work, and of their combined meaning. Even if a certain viewer feels what might be regarded as very legitimate offence when reacting to this work, another viewer could still, equally legitimately, find in this work many other layers of meaning. This should make us alive to the impossibility of discerning or defining one 'right' or 'complete' meaning of any work of art, including the other works of Christian art examined in this book. The modern viewer's reaction to the Clarisse Master's *Virgin and Child* (Fig. 4), for example, might differ significantly from the original 13th-century viewers' reactions, because the modern viewer approaches the work from a completely different cultural and historical standpoint. The work remains the same, but is seen and understood differently. To acknowledge the possibility of variant understandings of such works as the Clarisse Master's *Virgin and Child* or Chris Ofili's *The Holy Virgin Mary*, and to acknowledge that these understandings – even if they differ from anything the artists might have intended or envisaged – might nevertheless be valid, or interesting, is not simply to declare that 'anything goes'. But it does acknowledge that the viewing and understanding of works of art can change and vary.

The final work to be examined here is another that has been at the centre of controversy. The most well-known work of American photographer Andres Serrano (b. 1950) is entitled *Piss Christ* (Fig. 26). This photograph of a crucifix suspended in a mixture of urine and cow's blood has caused a storm on more than one occasion. In 1989 the existence of this photograph came to the attention of the US Senate, and several senators expressed outrage at the subject matter of the work, and at the fact that Serrano had received $15,000 from the American National Endowment for the Arts and Humanities in support of his work. More recently, the National Gallery of Victoria, in Melbourne, Australia, was forced to close down its 1997 exhibition of work by Serrano, after *Piss Christ* was attacked and damaged by two members of the public. Christian groups in Melbourne had attempted to have the work banned from display before the attack and the eventual closure of the exhibition. Much of the controversy surrounding this artwork seems to have come essentially from factors almost external to the work itself: the fact that Serrano had been supported with money from the National Endowment for the Arts, which is funded by taxpayers' money, or the perceived offensiveness of the work's title, or the fact that some commentators did not regard this work as being 'art' and did not believe that it should be treated as such, displayed as such, or valued as such. A great deal of the debate sparked off by *Piss Christ* was dominated by more general issues such as the worthy use of public money, and the tension between freedom of expression and blasphemy, rather than analysis of the work itself.

So what are we to make of this work: what are we to understand by it, and how can we interpret it? Most obviously many were outraged by the combination of the most iconic image of Christianity – the Crucified Christ – with human bodily fluid, and felt that this work set out deliberately to provoke viewers to outrage. The artist almost certainly aimed to provoke a reaction, but what reaction? The fact that urine is involved is crucial here. But was the use of urine simply intended, as some of Serrano's detractors have claimed,

26. Andres Serrano, *Piss Christ*, 1987

to cause offence? Had the artist deliberately set out to show disrespect to this religious image, by placing it in urine? Some felt that this was tantamount to urinating on the crucifix. I would suggest that, even if some viewers and commentators feel that it was the artist's intention, or part of his intention, to be offensive, there are also other ways to interpret this work. Let us acknowledge that if Serrano had only used blood here this image might not have caused such huge outrage. It is, after all, much more common to associate Christ and his body with blood, because of his shedding of blood on the cross. We are used to seeing crucifixes running in blood, and the wounds of Christ spurting blood. While blood may be a bodily fluid that can cause unease, it is not reviled in the same way as a bodily waste product such as urine. The use of the slang or offensive word 'piss' in the title of Serrano's work reminds us that this fluid is wholly undesirable. The artist plays upon the viewer's discomfort, even outrage, at seeing the image of Christ crucified, suspended in a mixture of blood and urine, and almost certainly intends to shock, but to what end? I would suggest that the use of urine here is intended to introduce, or in fact restore, some shock to the image of the Crucifixion. After seeing countless reproductions of hundreds of years' worth of Crucifixion images, a modern viewer's reactions to the Crucifixion of Christ might become dulled. A shock such as the one provided by Serrano's *Piss Christ* might remind a modern viewer what the image of the Crucified Christ really means. The process of viewing the Crucified Christ through the filter of human bodily fluids requires the observer to consider all the ways in which Christ, as both fully divine and fully human, really shared in the base physicality of human beings. As a real human being Christ took on all the characteristics of the human body, including its fluids and secretions. The use of urine here can therefore force the viewer to rethink what it meant for Christ to be really and fully human.

In fact, seeking ways to stress Christ's humanity has often been one of the primary messages attempted by artists over many centuries,

when tackling the image of the Crucifixion. This sort of outrage, produced by artists' attempts to show Christ crucified in new ways, to make new points about his humanity, is not just a feature of the modern era. Because the image of Christ on the cross is such a central image of Christianity it has – and has always had – a very great power to shock and disturb when it appears in an unfamiliar form. In 1306, the bishop of London, Ralph Baldock, ordered a crucifix to be removed from the chapel at Coneyhoop, in the parish of St Mildred, Poultry, London. The records of this case, in the Annals of London, note the form of the cross: the horizontal cross arm was not of the customary design, and it seems that this crucifix must have been of the type known as a *Gabelkreuz*, a type of crucifix seemingly emanating from Germany, which characteristically used Y-shaped, or fork-shaped cross-arms, and a dramatically suspended, contorted and suffering Christ figure. Either the unfamiliar form of the cross, or the particular way in which the Christ figure was shown, or both, caused the cross to be described in the Annals as a *crux horribilis* (a 'horrible' or 'monstrous' cross). Just over a century later, the Florentine sculptor Donatello produced a carved wooden crucifix, now in the Bardi chapel in the church of S. Croce. This crucifix, according to Giorgio Vasari's *Lives of the Artists*, was criticized by Donatello's friend and rival, Filippo Brunelleschi, for seeming to show the body of a peasant rather than the body of Christ. This story, anecdotal though it may be, would seem to indicate that the attempt of the artist to show Christ's real humanity, through emphasizing the effects of his physical suffering upon his human body, was deemed, by some viewers, to be unsuitable or inappropriate.

Seen in the context of other artists' attempts to state anew the message of Christ's humanity and suffering, and with a knowledge of the ways in which artists have constantly stressed Christ's physicality, Serrano's *Piss Christ* does not necessarily have to seem as irreverent, as offensive, as keen to poke fun at the subject matter and at the discomfited viewer, as some critics have claimed. It is therefore clearly important to place works such as this in some kind

of historical context. To have some understanding of the Christian image tradition upon which Serrano, Ofili, and other artists such as (more recently) Damien Hirst, base their modern artworks is to be able to assess them in a more measured way than might otherwise be possible. And conversely, to have considered these modern works – and the reactions that they are capable of arousing – perhaps facilitates an enhanced understanding of the earlier works of Christian art considered in this book, and of other works not included here.

Glossary

Apocryphal Gospels: accounts of Christ's life, contemporaneous or near-contemporaneous with the Gospels of Matthew, Mark, Luke, and John, but not recognized as part of the New Testament.

apse: semi-circular or polygonal termination of the eastern end of a chapel or *sanctuary*.

Baroque: dramatic and heavily ornamented style of art and architecture prevalent in Europe from the late 16th to the early 18th century.

choir: part of church containing seats for the religious community or clergy.

crocket: carved ornament in form of curled leaf.

eucharist: church ceremony in which the Last Supper of Christ and his apostles is commemorated by the blessing of bread and wine; the elements of bread and wine thus consecrated.

finial: ornament on top of a spire, gable, etc, in form of curled flower or leaf.

fresco: wall-painting, in which paint is applied to fresh plaster, so that the colour binds into the surface of the wall as the plaster dries.

grisaille: painting in neutral tones or tones of grey.

historiated initial: an initial letter containing a figural image.

indulgences: remission of the time spent in *purgatory* as punishment for sins committed, after the guilt of the sins has been forgiven.

liturgy: the forms of public service and worship prescribed by a church.

lunette: semi-circular painting, or field within a painting; semi-circular architectural frame or opening.

mendicant: (when used of a religious order of friars) dependent on alms for sustenance (from Latin *mendicare* = to beg).

monstrance: container for displaying the eucharistic bread (from Latin *monstrare* = to show).

nave: western part of the church, usually the part accessible to the public.

predella: horizontal structure supporting the main panels of an altarpiece.

purgatory: place or condition of punishment in which those who die with their sins forgiven must nevertheless undergo a limited amount of suffering in order to pay for their sins.

pyx: container for safekeeping of the consecrated eucharistic bread.

recto: the right-hand pages of a book; the front of a sheet of parchment or printed paper; '48r' therefore denotes the front of the 48th folio, or sheet, in a manuscript or early printed book.

sanctuary: eastern part of the church, beyond the *choir*, where the high altar is placed.

spandrels: area between two arches, or between an arch and an area of vertical moulding or of wall.

tempera: generally any medium used to bind paint pigments, but often particularly refers to egg tempera, i.e. paint made using egg yolk as a binding medium.

verso: the left-hand pages of a book; the back of a sheet of parchment or printed paper; '48v' therefore denotes the back of the 48th folio, or sheet, in a manuscript or early printed book.

References

Introduction

Robert Milburn, *Early Christian Art and Architecture*, Ashgate, 1988, p. 181.

Chapter 2

Jaroslav Pelikan, *Jesus Through the Centuries*, Yale University Press, 1985, p. 95.

Chapter 3

Contarelli: translation in Catherine Puglisi, *Caravaggio*, Phaidon, 2000, p. 154.

Chapter 5

Mariet Westermann, *Rembrandt*, Phaidon, 2000, p. 35.

Hans Belting, 'The New Role of Narrative in Public Painting of the Trecento: *Historia* and Allegory', *Washington National Gallery: Studies in the History of Art*, 16 (1985), pp. 151–68, at p. 166

Further reading

Introduction

Robin Cormack, *Byzantine Art* (Oxford University Press, 2000)

Robin Cormack, *Writing in Gold: Byzantine Society and its Icons* (Oxford University Press, 1985)

Antonio Ferrua SJ, *The Unknown Catacomb: A Unique Discovery of Early Christian Art* (Geddes & Grosset, 1991), for excellent colour photographs of the Via Latina catacombs, discovered in the 1950s

John Lowden, *Early Christian and Byzantine Art* (Phaidon, 1997)

Thomas F. Mathews, *The Art of Byzantium: Between Antiquity and the Renaissance* (Weidenfeld & Nicolson, 1998)

Robert Milburn, *Early Christian Art and Architecture* (University of California Press, 1988)

Jaroslav Pelikan, *Imago Dei: The Byzantine Apologia for Icons* (Princeton University Press, 1990)

J. Stevenson, *The Catacombs* (Thames & Hudson, 1978)

Chapter 1

Michael Baxandall, *Painting and Experience in Fifteenth-Century Italy*, 2nd edn. (Oxford University Press, 1988), for further discussion on painters' (and preachers') conceptions of the Annunciation to the Virgin

Hilda Graef, *Mary: A History of Doctrine and Devotion* (Sheed & Ward, 1985)

Jacobus de Voragine, *The Golden Legend: Readings on the Saints*, tr William Granger Ryan (Princeton University Press, 1993)

M. R. James, *The Apocryphal New Testament: Being the Apocryphal Gospels, Acts, Epistles, and Apocalypses* (Clarendon Press, 1966)

Jaroslav Pelikan, *Mary through the Centuries: Her Place in the History of Culture* (Yale University Press, 1996)

Roger Wieck, *Time Sanctified: The Book of Hours in Medieval Art and Life* (George Braziller, 1988)

Chapter 2

Hans Belting, *The Image and its Public in the Middle Ages: Form and Function of Early Paintings of the Passion* (Aristide D. Caratzas, 1990), on the Man of Sorrows image and its development

Gabriele Finaldi, *The Image of Christ* (National Gallery, 2000; publ. to accompany an exhibition at the National Gallery, London, February–May 2000)

Peter Humfrey and Martin Kemp (eds.), *The Altarpiece in the Renaissance* (Cambridge University Press, 1990)

Jaroslav Pelikan, *Jesus through the Centuries: His Place in the History of Culture* (Yale University Press, 1985)

Miri Rubin, *Corpus Christi: The Eucharist in Late Medieval Culture* (Cambridge University Press, 1991)

Chapter 3

Peter Brown, *The Cult of the Saints: Its Rise and Function in Latin Christianity* (University of Chicago Press, 1981)

David Hugh Farmer, *The Oxford Dictionary of Saints* (Oxford University Press, 1978), which has an appendix of principal attributes of the saints

Rona Goffen, 'Nostra Conversatio in Caelis Est': Observations on the *Sacra Conversazione* in the Trecento', *Art Bulletin*, 61 (1979), 198–222

James Hall, *Dictionary of Subjects and Symbols in Art* (John Murray, 1974)

Jacobus de Voragine, *The Golden Legend* (as in Chapter 1)

Donald Weinstein and Rudolph M. Bell, *Saints and Society: The Two Worlds of Western Christendom, 1000–1700* (University of Chicago Press, 1982)

Chapter 4

Frances Carey, *The Apocalypse and the Shape of Things to Come* (British Museum, 1999; publ. to accompany an exhibition at the British Museum, Dec. 1999–Apr. 2000)

C. M. Chazelle, 'Pictures, Books and the Illiterate: Pope Gregory I's Letters to Serenus of Marseille', *Word and Image*, 6/2 (April–June 1990), 138–53

Lawrence Duggan, 'Was Art Really the "Book of the Illiterate"?', *Word and Image*, 5/3 (July–Sept. 1989), 227–51

L. D. Ettlinger, *The Sistine Chapel before Michelangelo: Religious Imagery and Papal Primacy* (Clarendon Press, 1965)

Marilyn Lavin, *The Place of Narrative: Mural Decoration in Italian Churches, 431–1600* (University of Chicago Press, 1990)

Elvio Lunghi, *The Basilica of St Francis at Assisi* (Thames & Hudson, 1996)

Chapter 5

Owen Chadwick, *The Reformation* (The Penguin History of the Church, 3; Penguin Books, 1990)

A. G. Dickens, *The Counter Reformation* (Thames & Hudson, 1968)

Eamon Duffy, *The Stripping of the Altars* (Yale University Press, 1992)

Sergiusz Michalski, *The Reformation and the Visual Arts: The Protestant Image Question in Western and Eastern Europe* (Routledge, 1993)

Michael A. Mullet, *The Catholic Reformation* (Routledge, 1999)

Andrew Pettegree, '"The Law and the Gospel": The Evolution of an Evangelical Pictorial Theme in the Bibles of the Reformation', in Orlaith O'Sullivan (ed.), *The Bible as Book: The Reformation* (British Library and Oak Knoll Press, 2000), pp. 123–35

Index

Page references in *italics*
refer to illustrations.

Index

Christian Art